Drawing and Coloring Book

ROBOTS

ART AND STORY BY
Erik DePrince

WRITTEN BY
Erik DePrince and Jess Volinski

DESIGN ORIGINALS
an Imprint of Fox Chapel Publishing
www.d-originals.com

THE RISE OF THE UNITED EARTH ENFORCEMENT (UEE)

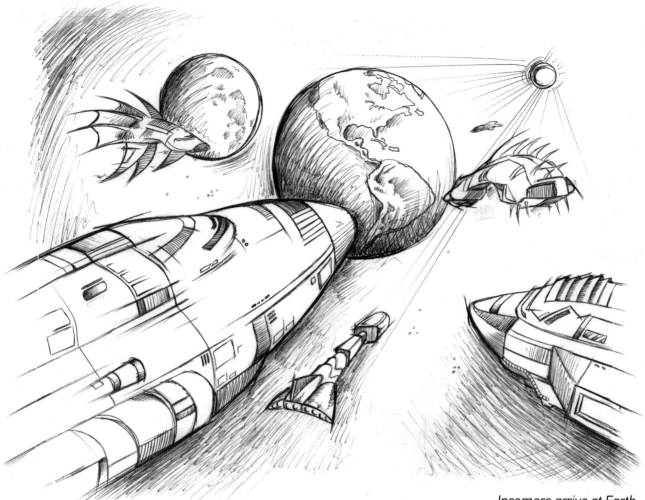

Incomers arrive at Earth.

Earth, 2216. After searching for signs of life in the universe for hundreds of years and finding nothing, we humans abruptly learned that we were not alone when delegates from the Universal Empires (UE) stopped by our planet for a visit. It was not quite the monumental first-contact moment of human triumph that we had envisioned. We were, after all this time, simply aliens to other worlds and not the center of the universe after all. In fact, we learned that Earth was about as far from the center as possible. To the UE, Earth was young and naive, a tiny planet, orbiting a tiny sun, in a relatively small galaxy on the edge of a large galactic cluster just beyond the borders of any of the major Empires. While we'd been stumbling around in the dark hoping to bump into another intelligent race, powerful empires had risen and fallen and risen again. We were completely out of the loop.

The human race was stunned. Not only were we not alone, we were completely insignificant. The entire planet's perspective irreversibly changed. During the UE delegates' visit to see our planet firsthand, they make a half-hearted offer for Earth to join the conglomerate of empires. To them, we were a distant island with little to no useful resources and certainly posing no threat. So when Earth's delegates declined, the UE simply walked away. There was no negotiation, no fight, no attempt to take our planet by force as we narcissistically assumed. Earth was simply too far away, too small, and too useless to serve any meaningful purpose to the mighty UE.

But now the doors were open. We were on the map, and there was no going back. Life on Earth could never be the same again. News spread quickly among the other worlds of a habitable planet rejected by the Empires and beyond their mighty reach, a place of hope and new beginnings...

So began the influx of alien entities to Earth. Incomers, they were called, looking for a better life away from the rule of the UE. First it was only the unwanted, the exiled, and the war refugees who found their way here. We were sympathetic. Then came families and merchants hoping for a prosperous new life in a new land, and our sympathy began to

medicines. Many incomers, feeling deeply indebted to their new home, were willing to work with the UEE in any way they could. Unlike other planets that primarily had only one race, Earth was now home to many different races, all bringing the benefits of their unique technology and perspective. Together, we became so much more than the sum of our parts.

The UEE poured huge amounts of resources into alien technology research and incorporated many of these reverse-engineered advancements into existing robots and mechs. The UEE's forces quickly expanded beyond humans and incomers to the creation of artificially intelligent (AI) entities. Life itself was

Before long, the UEE had a massive and varied robotic army keeping order on the planet.

waver. There were so many alien races, with so many customs, languages, rules...it was overwhelming. And with resources already spread thin on our planet, many worried the strain of this increased population could leave the planet weak and vulnerable to attack.

Earth had to adapt fast. Crime and violence rose as it became apparent that a planet overlooked by the UE would be a particularly appealing destination for all the criminals of the universe. Organized crime exploded, and smugglers imported banned and dangerous items to sell and trade. If humans wanted to maintain control of Earth, rules needed to be made—and enforced.

So an organization grew out of the chaos. For the first time in Earth's history, all the countries of the world worked together for a common goal. In 2228, the United Earth Enforcement (UEE) was formed, a multinational police force spanning the Five Regions of Earth, specifically established to ensure the safety and security of the planet.

Earth's new role as an intergalactic hub was not without benefits. Incomers brought with them more than just the customs of their home worlds. They brought technology, information, weapons, and

reassessed as laws such as the Entity Equality Rights Bill was written to grant AI beings rights. Before long, the UEE had a massive and varied robotic army keeping order on the planet, fighting the growing criminal groups, and even mounting defense against off-world invaders. We were finally protected. It was the great irony of our time, that a planet full of alien criminals would actually cause Earth to be safer in the universe.

Now, 10 years after the UEE was established, word of our technological growth and new defenses is starting to spread. Our planet is being noticed again. Some voices in the Empires have begun to whisper, "Maybe Earth is not such a wasteland after all. Maybe there is some value there..."

Amid all the diversity now on Earth, one thing is clear: it's in everyone's best interests to remain united—however uncomfortably—and together stand so strong that no empire would dare invade. Earth is neutral ground, and, despite our many differences, we are all willing to fight to keep it safe from threats both near and far. And now we've got the robot army to do just that.

7 STEPS TO CRAFTING A CHARACTER

1. Planning
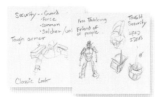

2. Creating a Framework
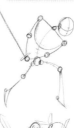

3. Blocking in Shapes
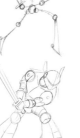

4. Defining Forms
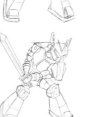

5. Refining Forms
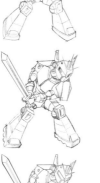

6. Inking the Final Lines

7. Adding Color
- Light Source and Shading
- Blocking in Color
- Gradients
- Shadows
- Highlights

In this drawing and coloring lesson, I'm going to guide you through my process of crafting an original character, from initial notes to final colored art, in 7 basic steps.

DRAWING MATERIALS YOU'LL NEED

- **PENCILS:**
Any pencil you're comfortable with will work, but I recommend mechanical pencils with .5 mm lead in either H or HB hardness.

- **PAPER:**
You'll want a smooth, high-quality paper that can hold ink without smearing and handle a lot of erasing without tearing. I recommend bond paper, bleedproof paper, or a thick, high-quality copy paper.

- **ERASERS:**
Have a variety on hard, and don't be afraid to use them! I especially like the thin retractable kind to get into smaller areas.

- **PENS:**
Everyone has favorite pens, so I recommend you use what you're most comfortable with. Have a variety of tip sizes on hand so you can vary the thickness of your lines. If you plan to color with markers right on your final drawing, be sure whatever pens you use are waterproof.

- **PEN TABLET (OPTIONAL):**
If you prefer to draw digitally, I highly recommend using a Wacom pen tablet.

1 PLANNING YOUR CHARACTER

Let's get started! In order to successfully create an original character, you need a plan before you begin your drawing. Here are some suggestions to get you thinking.

- **Name your character:**
Who is this character?

- **Make a word list:**
Pick a few words that describe your character. Think about both their physical appearance and personality.

- **Visualize your character:**
What does your character look like? Make a few quick sketches of ideas you have and write down some of your character's defining physical characteristics.

- **Clothing/accessories:**
If your character wears clothing, what does it look like? Does your character have different clothing for different activities?

- **Equipment:**
Does your character use any defining objects? Draw a few sketches of any equipment your character uses.

- **Build a world:**
Imagine the world your character will live in; jot down some ideas about where your character lives, locations your character might visit, and story ideas.

- **Get inspired:**
Look at great artwork you admire—but be sure you develop your own unique style!

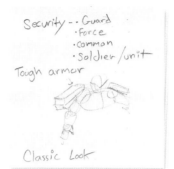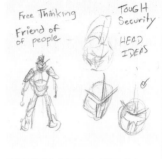

My planning notes.

MY PLAN

I've decided that the character I'm going to draw will be called a **UEE Security Force Guard Unit** robot. It's a big, strong robot that is used as a security guard at events and carries a giant sword.

WORLD BUILDING

For me, as an artist and storyteller, a big part of my character design and development process is **world building**. Characters don't exist in a vacuum; for a character to live and breathe, it needs to be part of a world. I spend a great deal of time imagining the worlds my characters inhabit. On the back of each coloring page in this book, you'll see the profile I developed for each character. I could certainly draw characters without all this information, but thinking it through helps me create characters that are more than just drawings on a page—they are each part of a bigger story.

2 BUILDING THE FRAMEWORK

Before you start drawing your character, it's important to establish what's inside of it. Imagine there are wires inside your character, and draw its **internal framework**. In your sketches, identify all the most important parts of your character, such as key joints, head position, hips, arms, and legs, with simple shapes. These framework drawings are also called **armatures** or **gesture drawings**. Create several of these loose sketches of your character in different poses so you can understand your character's internal structure and how that affects how your character moves through space. The key at this stage is to work fast and draw lots of sketches; don't get too hung up on how well drawn they look. Once you have a favorite pose, use that sketch as a blueprint to follow as you construct your character in the next steps.

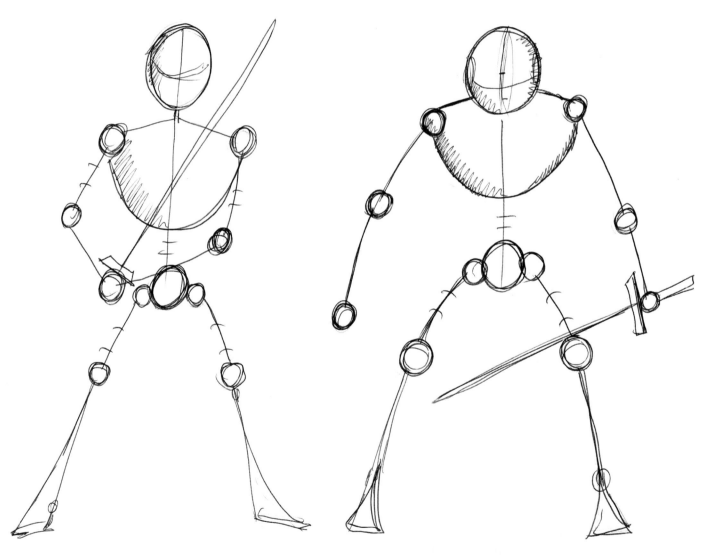

Quick framework sketches showing different poses of the UEE Security Force Guard Unit.

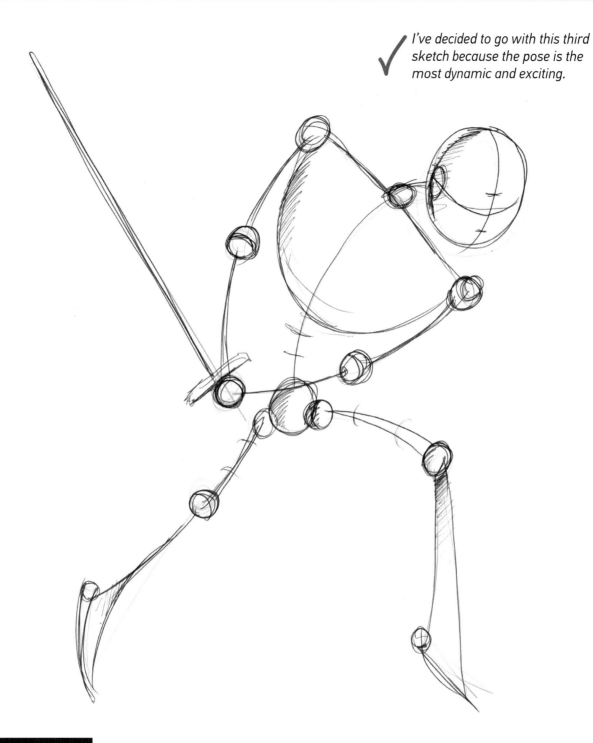

I've decided to go with this third sketch because the pose is the most dynamic and exciting.

KEEP IN MIND

Think of a drawing as something you craft. In order for it to be believable and well constructed, you will need to start by creating a strong internal structure. This is the most important part of your drawing. If your structure is weak, your character will be weak. If your structure is strong, it will easily be able to support the shapes and forms you will add to it in the next steps.

❸ BLOCKING IN THE SHAPES

Now that you understand your character's pose, start blocking in large, flat shapes to indicate the head, body, arms, and legs. Remember, you're building all of this right onto the framework you established in Step 2. You can draw right on your framework drawing, or, if you have one, you can use a light table to draw on a new piece of paper with the framework drawing underneath. Remember that you're only using flat shapes in this step. They can have a hint of three-dimensional form, but it is most important at this stage to focus on blocking in the basic shapes.

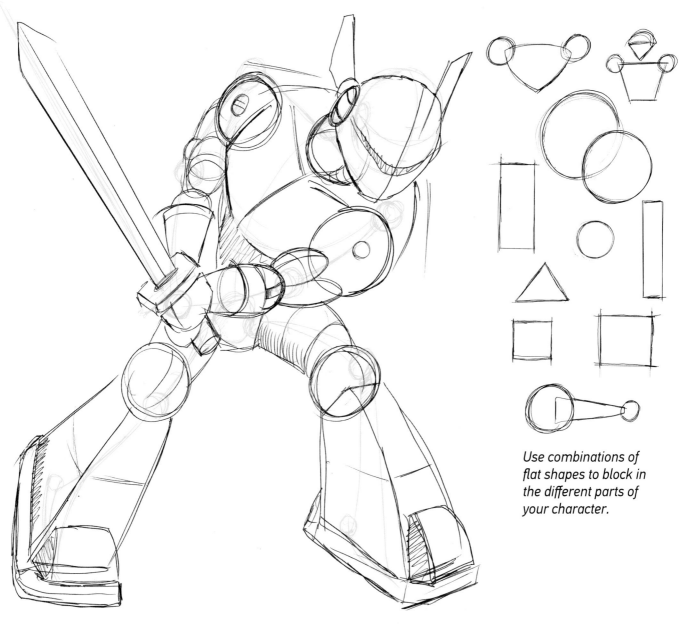

Use combinations of flat shapes to block in the different parts of your character.

*Keep your character's internal framework in mind as you build up shapes on top of it. Remember: your framework is **inside** your drawing, providing support for the shapes.*

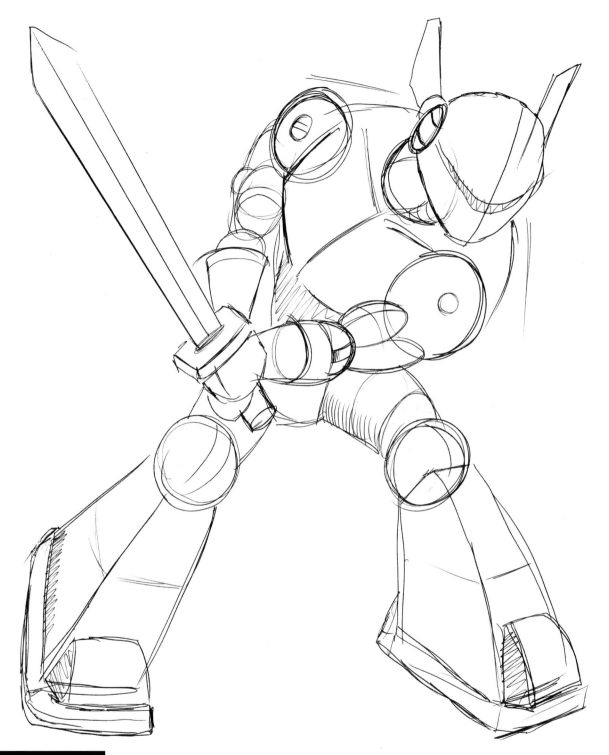

KEEP IN MIND

Make sure that when you are drawing your shapes you do not lose the essence of the framework. It's important at this step to also establish proper proportions in your character. Take your time to make sure that both arms and both legs are equal lengths and all the limbs connect to the framework properly.

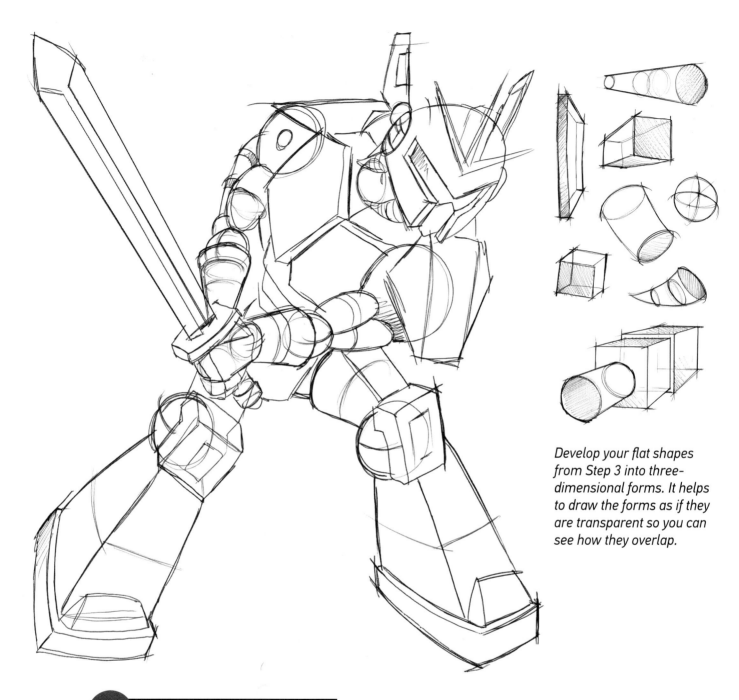

Develop your flat shapes from Step 3 into three-dimensional forms. It helps to draw the forms as if they are transparent so you can see how they overlap.

4 DEFINING THE FORMS

Next, develop the flat shapes from Step 3 into three-dimensional shapes called **forms**. These forms are the building blocks of your character; they give your character volume and make it feel real. Think about how each form interlocks, overlaps, and intersects each surrounding form. In this step, draw all the forms of your character as if they are transparent so you can see through them to make sure each part fits together in a way that makes sense.

5 REFINING THE FORMS

Once you are happy with all the forms you built up in Step 4, you can continue to refine your drawing. Erase the lines that made your character's forms look transparent. Continue to build up details with smaller forms that pop off your character's surface. You'll know you're ready to move to Step 6 when your character feels very solid and looks complete to you.

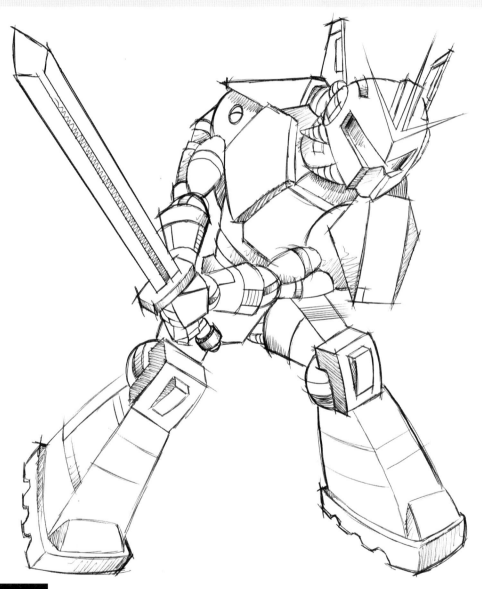

KEEP IN MIND

If you get this far and aren't loving what you've drawn, do not get discouraged! It's okay to make an ugly picture. I've made many, believe me—they just don't end up in a book, so you never see them. (Plus, I usually rip them up.) You'll learn a lot more from doing things wrong than you will from doing them right. So learn from your ugly drawing, rip it to shreds if that helps, and then try again from Step 1.

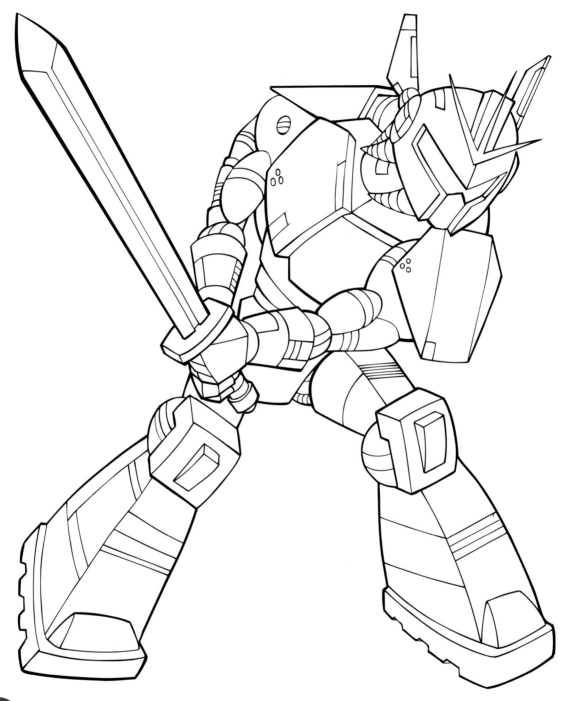

6 INKING

Once you are happy with your finished drawing from Step 5, you can create the final inked line drawing, either with black pens or digitally. Keep the original underlying forms in mind when you're inking these final lines. This is the stage to add any additional surface details as well. You can redraw your Step 5 drawing on a new sheet of paper if you want to save the drawing, but I usually ink right onto the final drawing and erase the pencil lines afterward.

7 ADDING COLOR: LIGHT SOURCE AND SHADING

Before getting started with color, it's important to identify your light source and understand how light falls on the forms of your character. A light source can be natural light from the sun or artificial light from a lamp. The key is to make sure all the forms are illuminated from a consistently positioned light source so all light that falls on your character is coming from the same direction. This will make your character feel solid and look believable.

Make a few copies of your inked drawing (or scan it so you can work digitally) and practice understanding light sources by shading your drawing with just gray tones. This is called a **tonal study**. Forget about color for a moment—instead, imagine your character as a three-dimensional model made out of white clay. How would the light fall on each form? Lighting from above makes a character look very different than lighting from below or from the side. Once you have a tonal study you like, you can use it as a guide for adding color to your inked drawing in the next few steps.

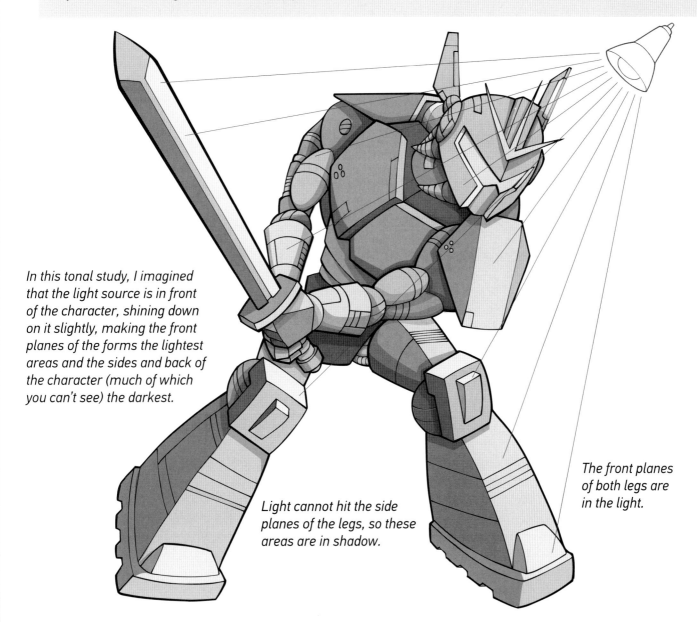

In this tonal study, I imagined that the light source is in front of the character, shining down on it slightly, making the front planes of the forms the lightest areas and the sides and back of the character (much of which you can't see) the darkest.

Light cannot hit the side planes of the legs, so these areas are in shadow.

The front planes of both legs are in the light.

8 ADDING COLOR: BLOCKING IN COLOR

The first step to coloring your character is deciding what colors you will use. Then, fill in each area with a few medium to light tones of your colors. For now, keep these base colors very simple, flat, and not too dark—you're not thinking about shadows or highlights yet, only blocking in what colors go in each area.

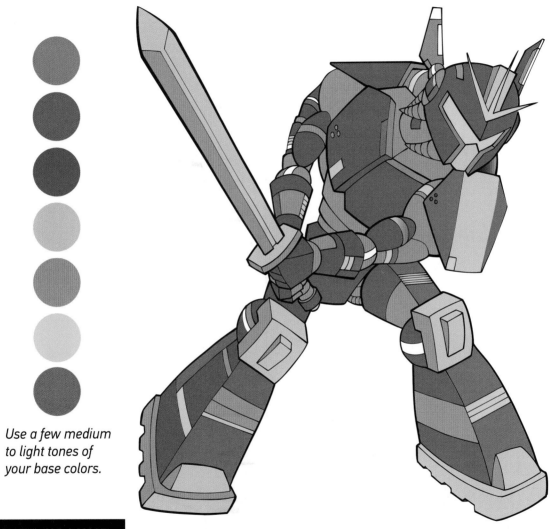

Use a few medium to light tones of your base colors.

KEEP IN MIND

Coloring is a very personal process; every artist has a favorite way to color. I love to work digitally, so I bring my final inked drawing from Step 6 into my computer and color it using a Wacom pen tablet in Adobe Illustrator and/or Photoshop. If you prefer to work with markers, paint, or other non-digital media, be sure to ink Step 6 on the kind of paper you like to color on; and, if you plan to use a wet medium like markers, be sure your black lines are drawn with a waterproof pen so they don't bleed. Even though I am using a digitally colored example here, the ideas of the lesson apply to any media you might work in. I spent many years working with markers, colored pencils, and oil paint using almost the exact same process of coloring that I now do digitally.

9 ADDING COLOR: GRADIENTS

Now that you have your color blocked in, it's time to begin giving your forms more dimension by adding **gradients**. Gradients are areas that blend softly across a color from light to dark to create a smooth color transition, and they should follow your character's forms. Refer back to your shaded drawing in Step 7 and use that as a guide for where your lights and darks should be. Darken areas in shadow with gradients that progress smoothly across each form, blending with the underlying base tones of color. You spent a lot of energy crafting your character out of three-dimensional forms. Now it's time to use color, light, and shadow to enhance and accentuate those forms.

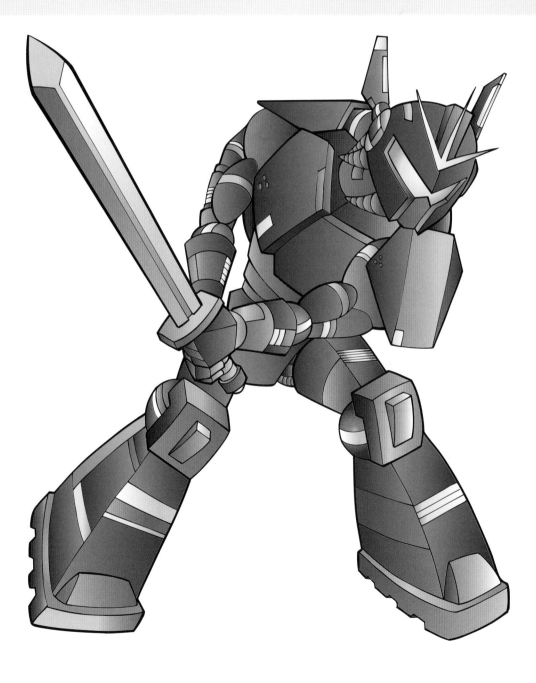

10 ADDING COLOR: SHADOWS ▼

Now it's time to deepen your shadows. Keep referring back to your tonal study from Step 7, and darken the areas where the light from your light source does not hit with deeper, darker shadows. Your character should look almost done and feel very solid now.

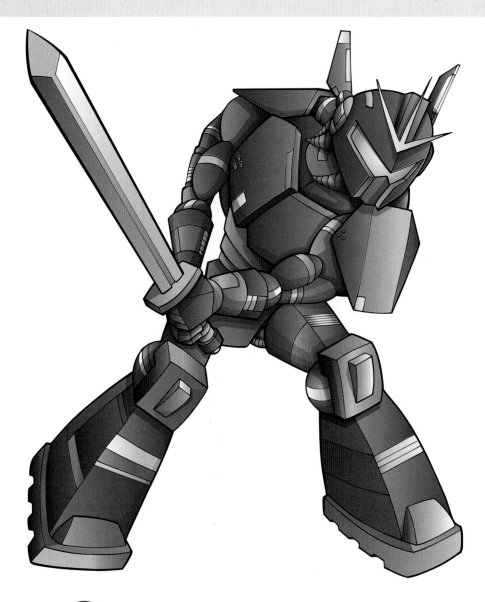

11 ADDING COLOR: HIGHLIGHTS ▶

All that's left to do is add highlights. These are subtle areas of a very light tone added to places where the light hits your character most directly. You can see how adding highlights in this step helps define the edges between forms, makes lighter areas pop, and adds a glossiness to the robot's surface. The UEE Security Force Guard Unit is now complete!

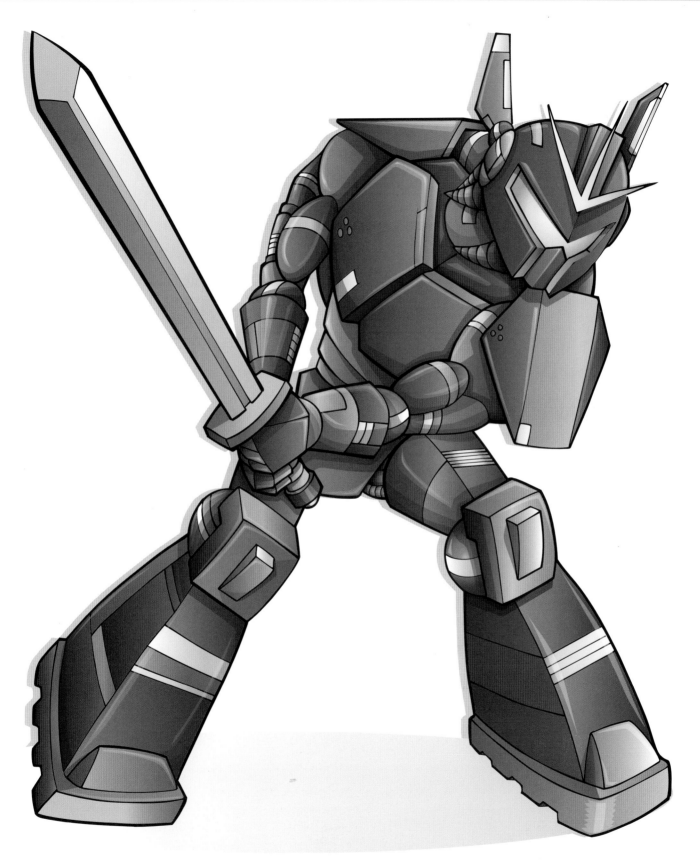

UEE SECURITY FORCE GUARD UNIT

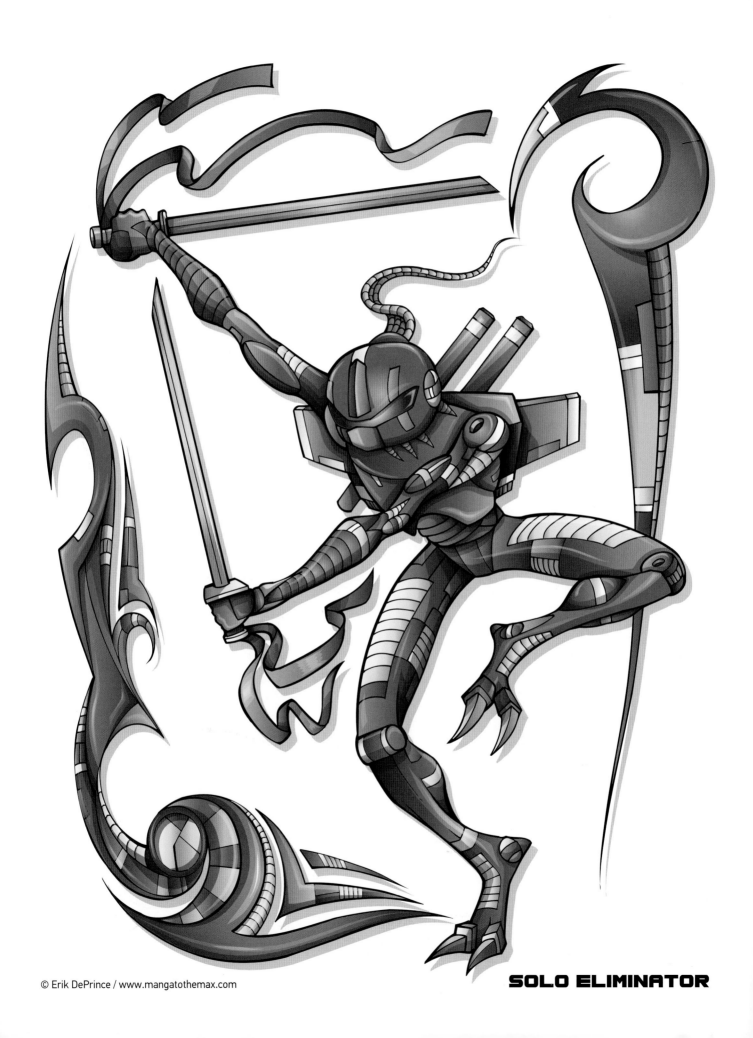

© Erik DePrince / www.mangatothemax.com

SOLO ELIMINATOR

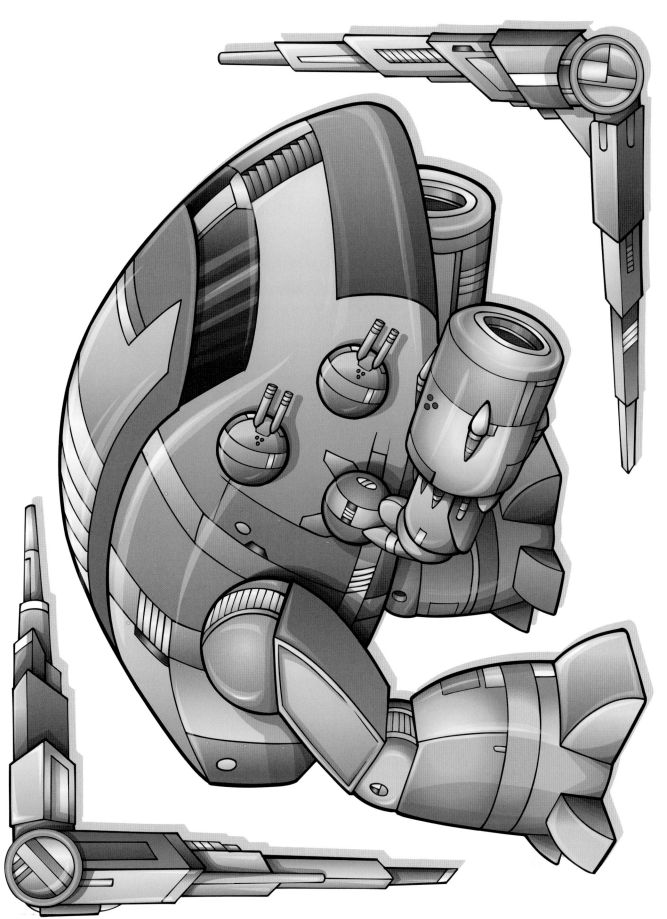

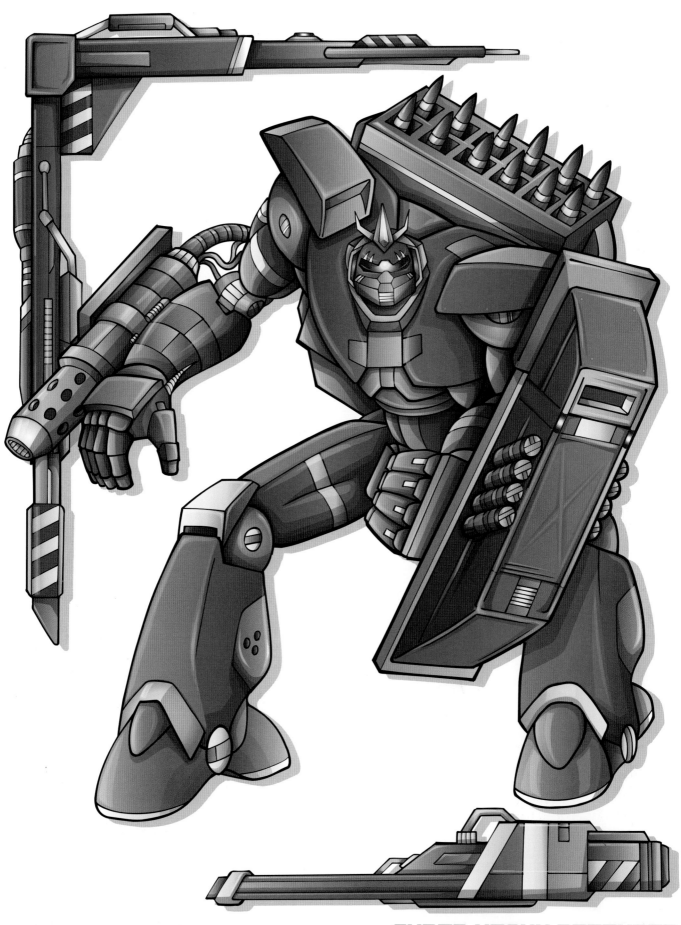

© Erik DePrince / www.mangatothemax.com

SUPER HEAVY DEFENDER

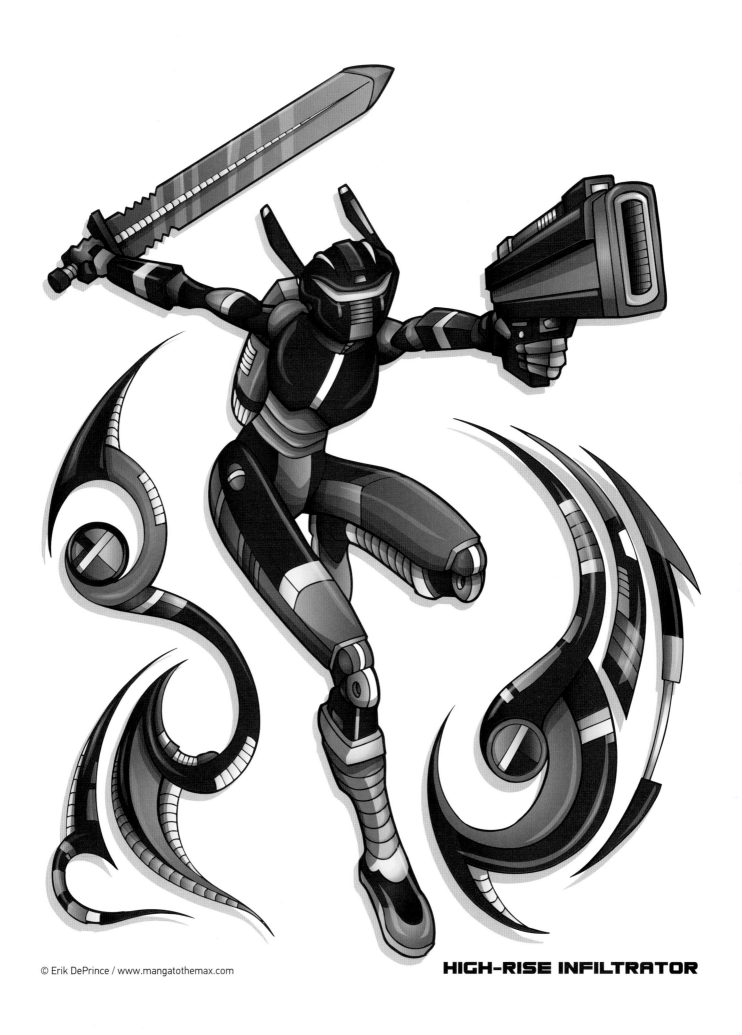

© Erik DePrince / www.mangatothemax.com

HIGH-RISE INFILTRATOR

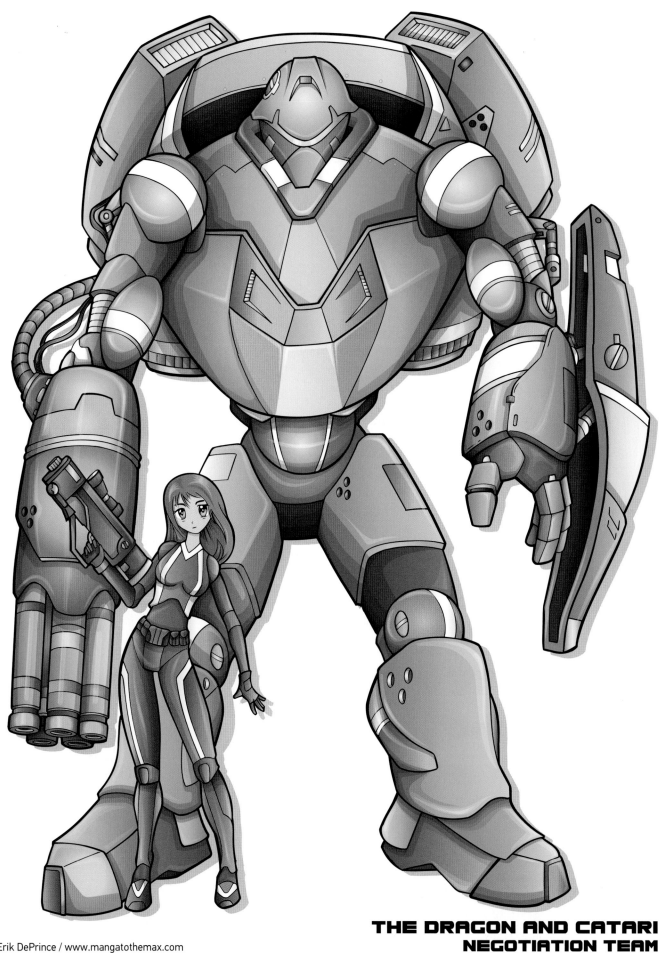

THE DRAGON AND CATARI
NEGOTIATION TEAM

STREET RUNNER

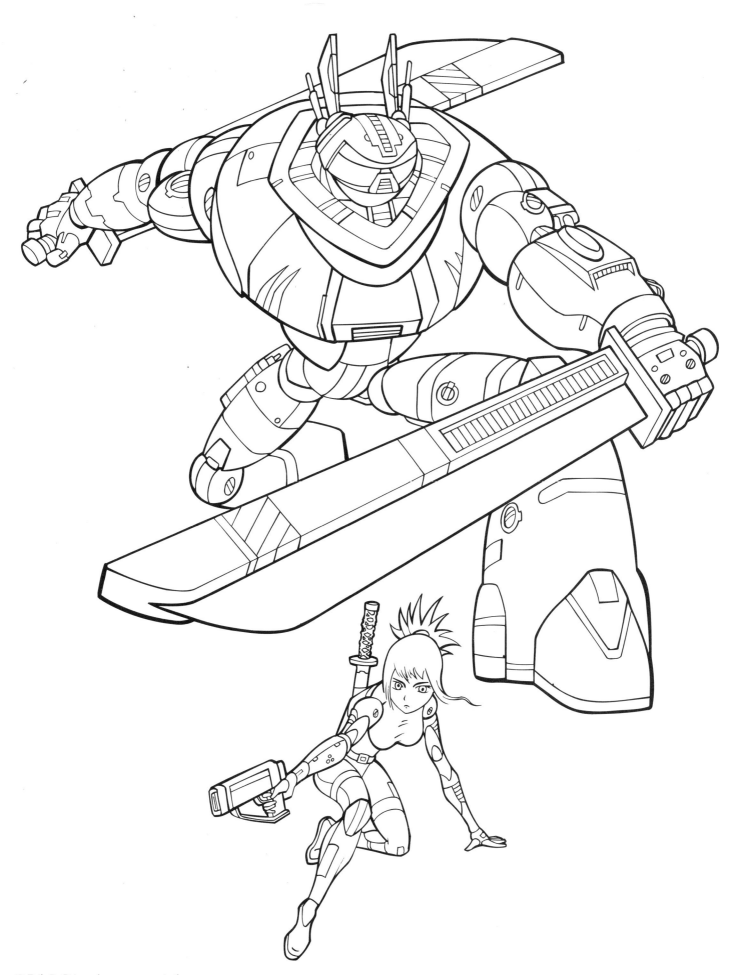

STATS

TORRIN
- Robotic Class: Artificial Intelligence (AI) (sentient)
- Size: 10 ft. (3.05 m)
- Offensive Capabilities: Siege Blade
- Defensive Capabilities: Heavy armor

SINCARI
- Robotic Class: Cyborg, human-born (sentient)
- Size: 6 ft. (1.83 m)
- Offensive Capabilities: Martial arts
- Defensive Capabilities: Super-strong alien arachnid-silk armor, evasion skills

PROFILE

Negotiation Teams, essential parts of the United Earth Enforcement (UEE), work together as detectives, investigating crimes and negotiating with alien criminals. Together, Torrin and Sincari are one of the most successful, well-known teams in the UEE. Torrin is a former Urban Ground Defender (UGD) robot, upgraded by Sincari to have artificial intelligence (AI). UGDs are typically used in urban SWAT raids expected to meet heavy resistance and specialize in breaking into heavy bunkers and vehicles. The UGD is also the only UEE unit able to wield the Siege Blade. Sincari is a human-born cyborg. She is an expert in martial arts and has extensive telekinetic abilities, including mind control over animals. This skill is particularly useful for controlling dangerous alien animal-like creatures.

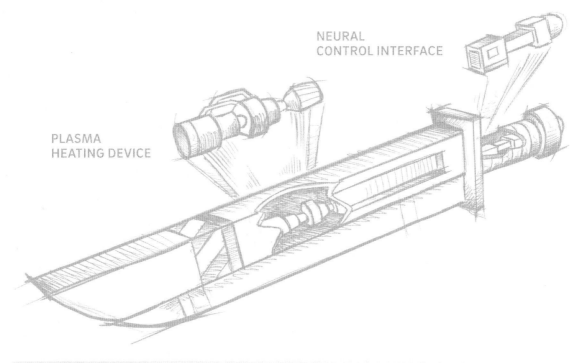

NEURAL
CONTROL INTERFACE

PLASMA
HEATING DEVICE

▲ SIEGE BLADE (above)

Torrin's unique Siege Blade is a 4,000 lb. (1800 kg), 12 ft. (3.5 m) titanium sword that can only be used by UGDs. Right before impact, it utilizes a specialized plasma technology to heat the blade to more than 2,000 degrees Fahrenheit (1,000 degrees Celsius), helping it slice through steel and vaporize many materials on contact.

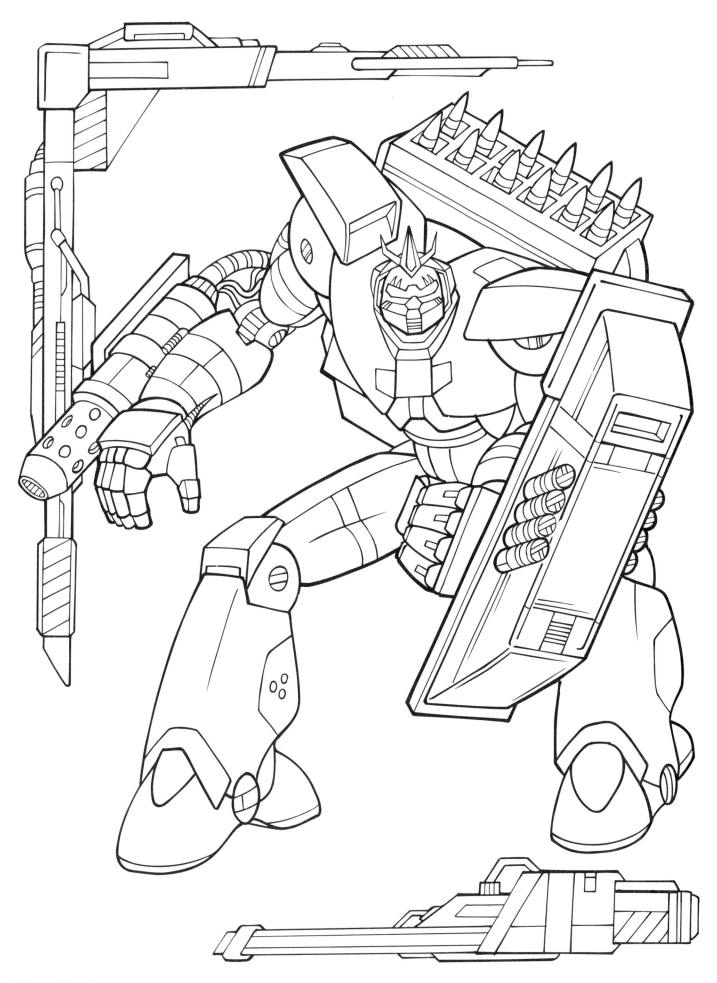

STATS

- Robotic Class: AI (sentient)
- Size: 40 ft. (12.19 m)
- Offensive Capabilities: Missile Launcher
- Defensive Capabilities: Anti-artillery shield and personal forcefield

PROFILE

Super Heavy Defenders (SHDs) are specifically used for protecting Earth from the threat of large-scale incursions. When alien incomers first started arriving on Earth, not all were peaceful. Some races came armed with ships and ground forces, eager to take over this out-of-the-way planet but unaware of the resistance they would face from Earth's SHDs. Even now, a small empire will occasionally make a move to invade Earth, and, so far, every attempt has been easily repelled by the SHD forces. Not only are SHDs dangerously offensive with their missile array with short-range teleportation, they are also heavily defended with an anti-artillery shield, as well as their own personal forcefield. In an effort to avoid limitation from their mechanical bodies, SHDs developed the ability to remove their sentience and upload it into another compatible UEE robot if they are damaged in battle, making them virtually indestructible as long as there are extra UEE robot bodies available.

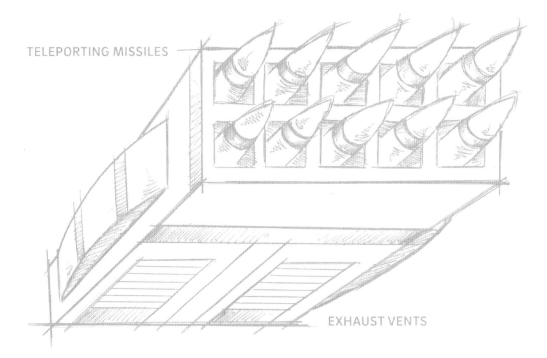

TELEPORTING MISSILES

EXHAUST VENTS

▲ MISSILE LAUNCHER (*above*)

Not only do the SHD's missiles have cloaking abilities so they are invisible to the enemy on approach, they are also equipped with short-range teleportation. This allows the SHD to control missiles, directing them to pass through ship walls and into hard-to-reach interior locations.

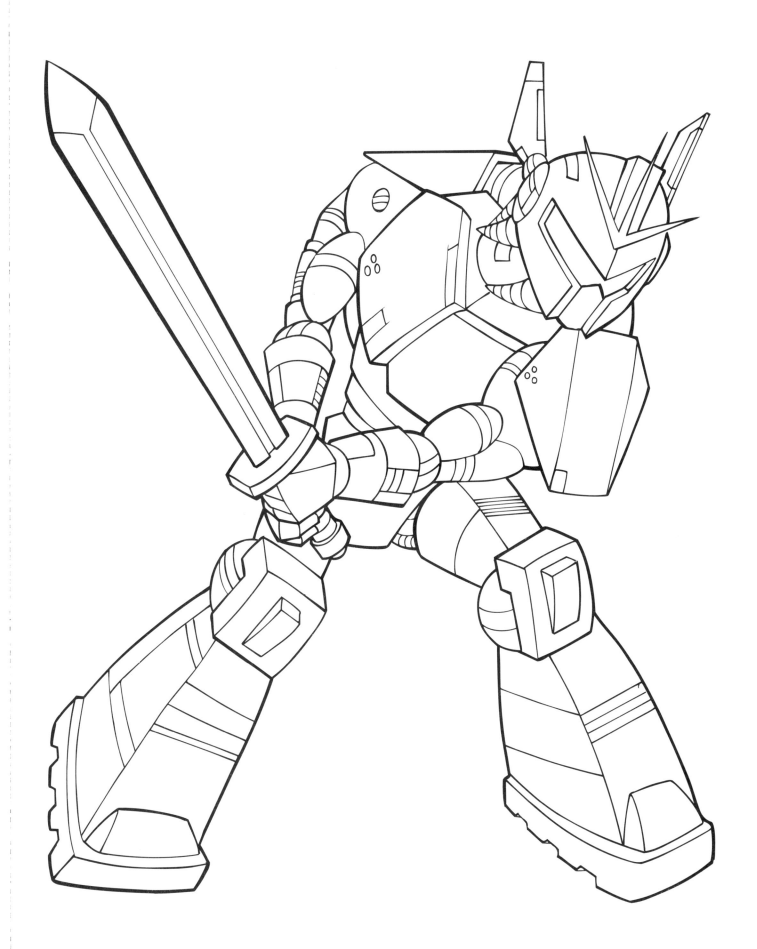

STATS

- Robotic Class: Mechanical (non-sentient)
- Size: 6.5 ft. (1.98 m)
- Offensive Capabilities: Stun Sword
- Defensive Capabilities: Heavy armor

PROFILE

The UEE Security Force Guard Unit (SFGU) is the security division of the UEE. Mostly used for guard patrol and security at events or gatherings—anywhere there are large crowds—each SFG robot works as part of a Guard Group, run entirely by its Control Unit at UEE Command. Heavily armored and considered virtually indestructible, the mere presence of SFGs is usually enough to keep crowds from getting out of hand.

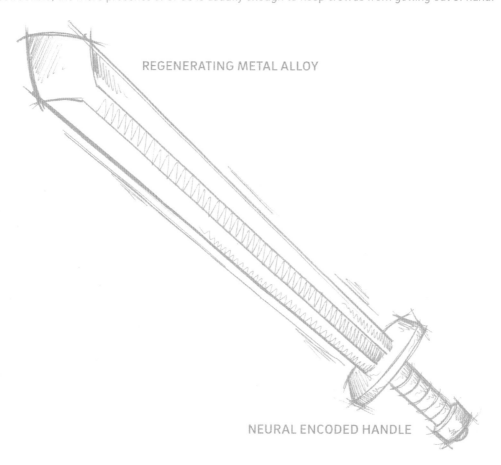

REGENERATING METAL ALLOY

NEURAL ENCODED HANDLE

▲ STUN SWORD *(above)*

Since SFGU robots are not free-thinking, they are not allowed to carry lethal blasters of any kind. Instead they are equipped with a Stun Sword that can send out a stunning pulse to subdue large groups when necessary. While not deadly, the stun is quite powerful and can be very painful. Each Stun Sword has a neural encoded handle which allows only the Guard Unit assigned to the weapon to wield it.

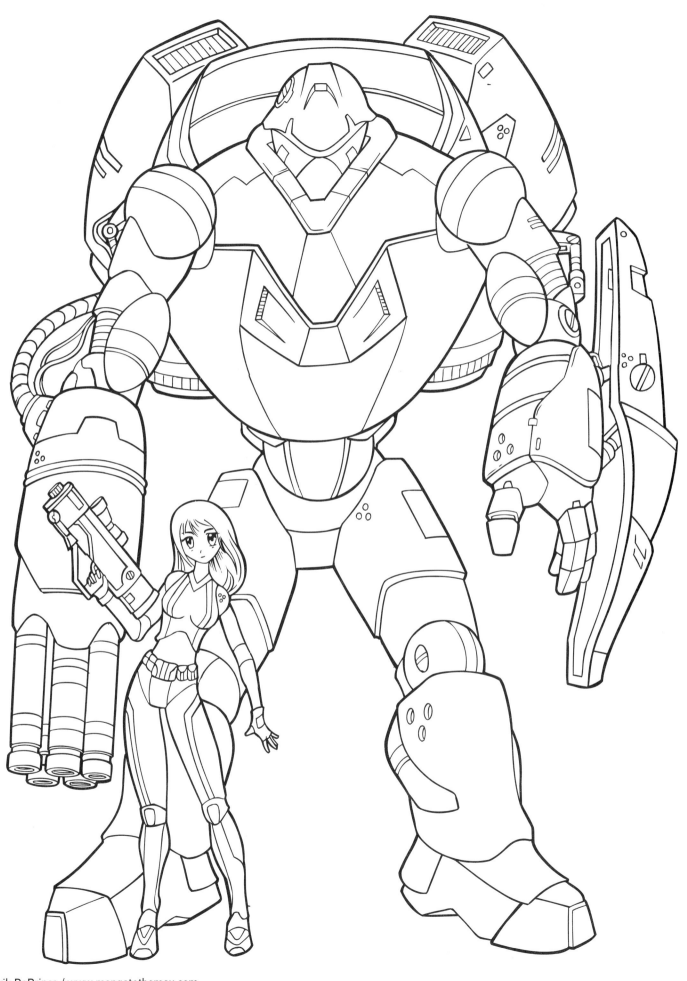

STATS

THE DRAGON
- Robotic Class: AI (sentient)
- Size: 11 ft. (3.35 m)
- Offensive Capabilities: Plasma Vulcan Cannon
- Defensive Capabilities: Shock Shield

CATARI
- Robotic Class: Cyborg, human-born (sentient)
- Size: 5.5 ft. (1.68 m)
- Offensive Capabilities: Martial arts
- Defensive Capabilities: Super-strong alien arachnid-silk armor

PROFILE

The Dragon and Catari are a Negotiation Team known for their keen detective work. He is battle-ready, silent, and intimidating. With a protective Shock Shield that can be expanded to protect Catari and the ability to fly with a rocket pack, the Dragon is equipped with strong defenses. Besides being big and dangerous, the Dragon is also a giant walking crime lab. He can scan crime scenes and instantly detect and analyze important information and clues. Catari is friendly and conversational. As a cyborg, she relates well to both organic entities and AI robots, a very important quality that helps in their investigations. Catari is also extremely knowledgeable in the languages and customs of all alien races on Earth, which helps tremendously in their investigations.

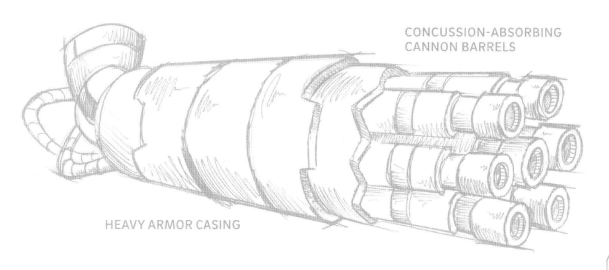

CONCUSSION-ABSORBING
CANNON BARRELS

HEAVY ARMOR CASING

▲ PLASMA VULCAN CANNON *(above)*

The Dragon's Plasma Vulcan Cannon can shoot 1,100 plasma rounds a minute. It's designed to go through armor, vault doors, and bunkers.

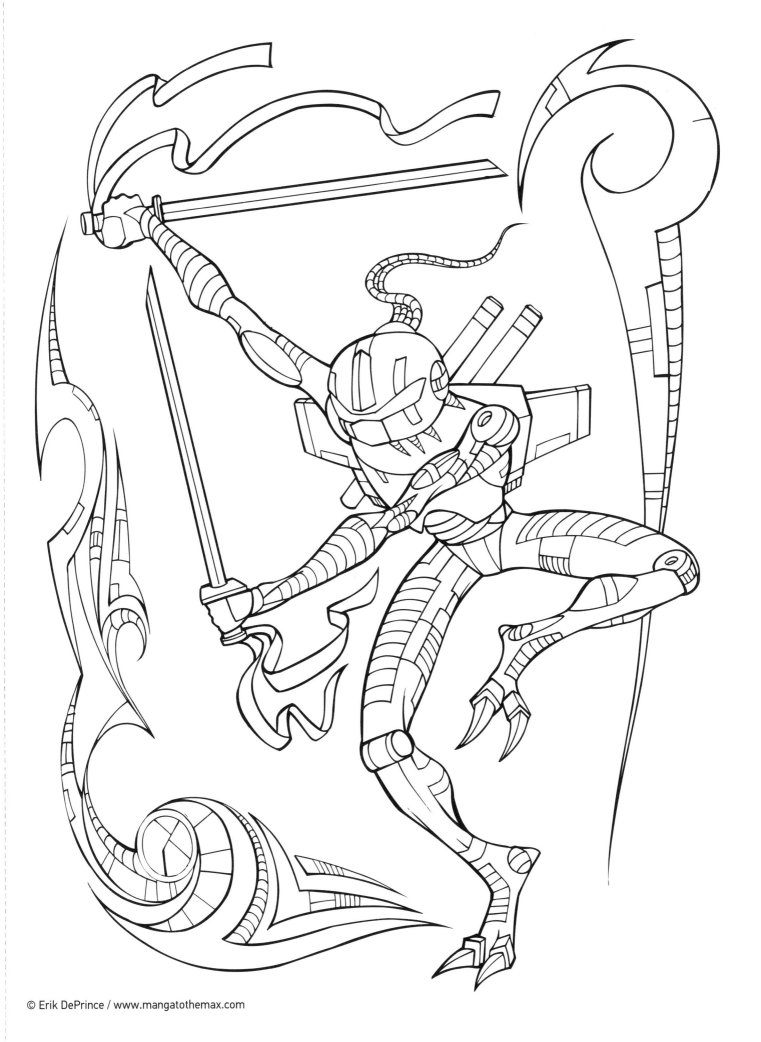

STATS

- Robotic Class: AI (sentient)
- Size: 6 ft. (1.83 m)
- Offensive Capabilities: Hand-to-hand combat
- Defensive Capabilities: Light armor, speed

PROFILE

An expert in stealth, the Solo Eliminator uses minimal force to neutralize targets. A small levitation pack helps it move around undetected. It is the UEE's first choice for ship and facility sabotage missions. With a short-range site-to-site transport, combined with its speed, an Eliminator can be in and out of areas before anyone ever realizes it was there. When it is necessary to directly engage a target, the Eliminator puts to work its hand-to-hand combat training.

STABILIZING GRAV RUDDERS

SPINAL NEURAL INTERFACE

▲ **LEVITATION PACK** *(above)*

Levitation packs were developed by the UEE from alien anti-gravity sound wave technology in order to help traditionally ground-based units have more mobility. It does not allow the user to fly or travel very quickly, but it does increase jumping distances, allows units to hover for periods of time, and helps units to easily pass over difficult terrain.

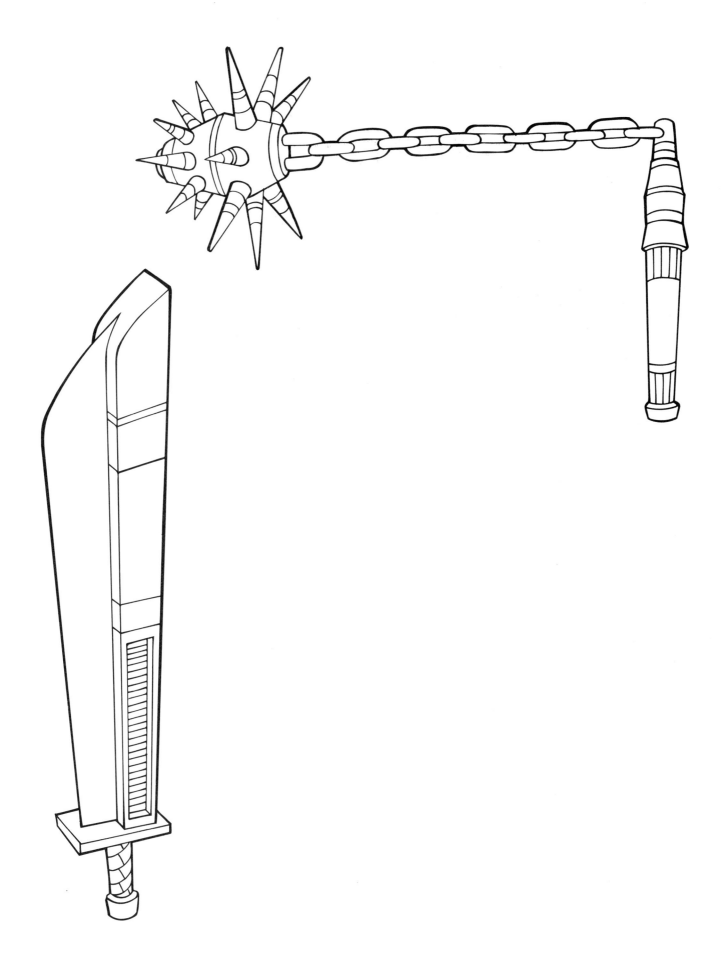

Draw your own original UEE robot weapons and create a profile about each one.

◀ WARSTAR (previous page, top)

Originally brought to Earth by alien incomers, Warstars are a very old alien technology. The Warstar is a super dense, electrified mace used in combat. Weighing about 660 lbs. (300 kg), they are primarily used by only the largest and strongest robots. Inside is a plasma charge cell that powers the Warstar seemingly indefinitely. No one knows how to recharge the plasma cells, though luckily no Warstars have yet run out of energy.

◀ SIEGE BLADE (previous page, left)

Siege Blades are made of titanium and can only be used by UGDs due to their extreme weight. Right before impact, a Siege Blade utilizes a specialized plasma technology to heat the sword to more than 2,000 degrees F (1,000 degrees C), helping it slice through steel and vaporize many materials on contact.

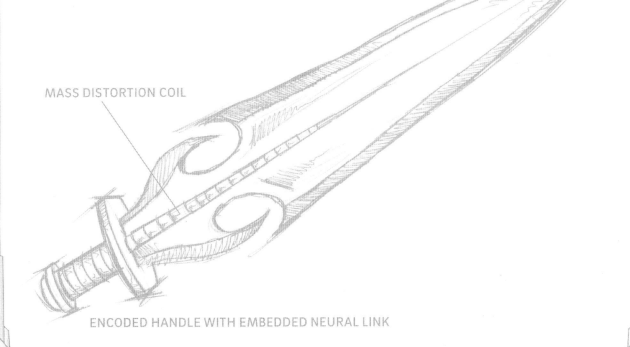

MASS DISTORTION COIL

ENCODED HANDLE WITH EMBEDDED NEURAL LINK

▲ THUNDER BLADE (above)

When the Thunder Blade hits an object, it generates a destructive shockwave. The user of the blade uses a neural link to control the force and direction of the shockwave.

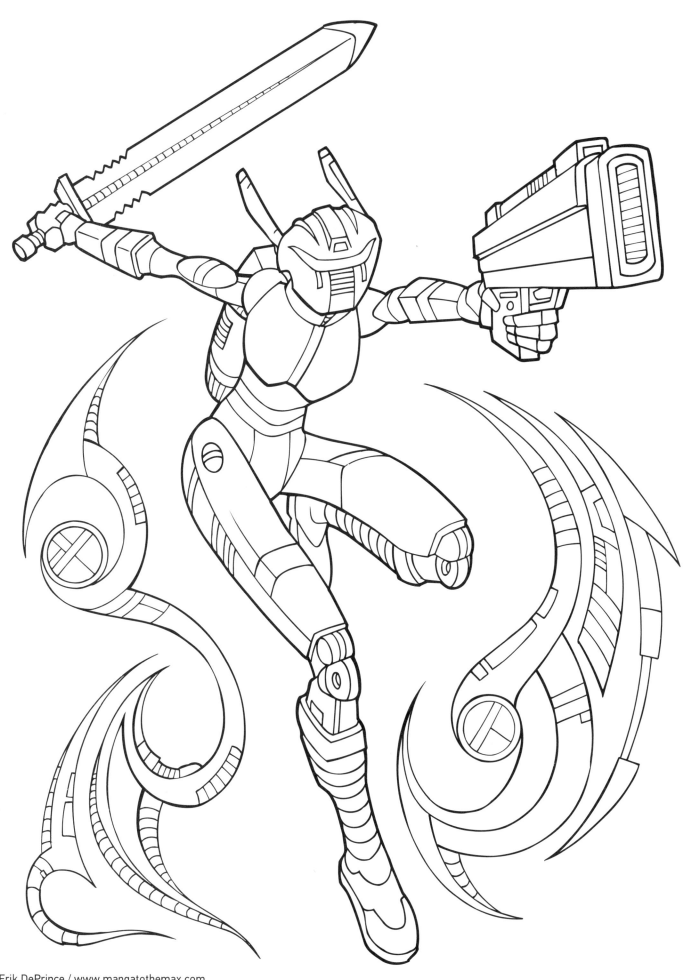

STATS

- Robotic Class: AI (sentient)
- Size: 6 ft. (1.83 m)
- Offensive Capabilities: Pulse Blaster, Thunder Sword
- Defensive Capabilities: Moderate armor, speed (rocket pack)

PROFILE

With the influx of incomers, Earth has faced many new challenges. One of the most interesting has been adapting to alien species that live in the air. Aerial races have built many amazingly tall buildings using their technology to create super-reinforced structures able to withstand the wind and elements so high in the atmosphere. Some races have even engineered floating landmasses to allow them to enjoy the unimpeded glory of the open-air, high-altitude living they were accustomed to on their homeworlds. The High-Rise Infiltrators (HRIs) are a UEE unit designed specifically to patrol these sky-high locations. They mainly work alone, each in an assigned sector of the sky. Using a specially designed rocket pack adapted to include a levitation mode, an Infiltrator can move fast and far (rocket mode) or slow and precise (levitation mode) to help maintain a UEE presence in remote aerial locations.

HEAVY ARMOR CASING

LASER X-RAY SCOPE

▲ **PULSE BLASTER** *(above)*

All HRIs are given standard-issue UEE Pulse Blasters. These blasters use super-heated plasma projectiles specially engineered to break through the super-reinforced glass of the new high-rises.

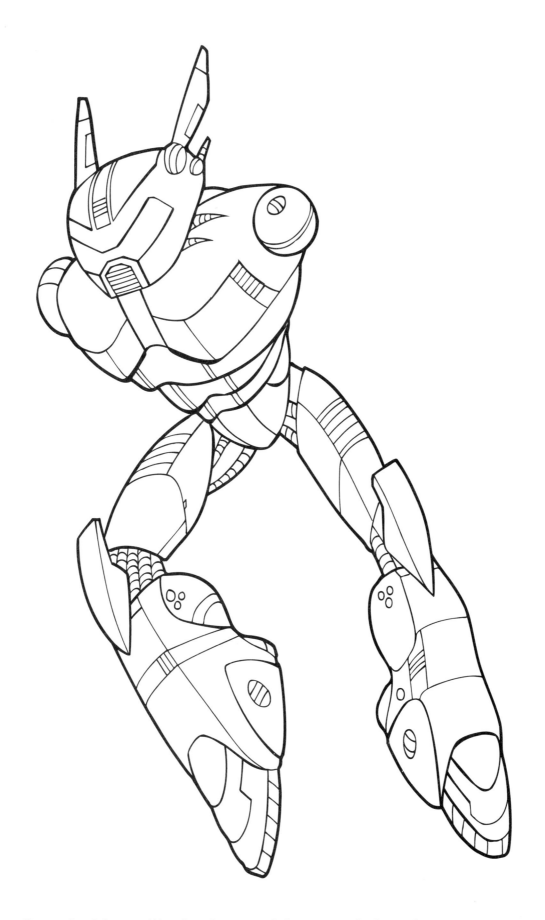

Draw the Adverse Weather Commando's arms and Blaze Claws.

STATS

- Robotic Class: AI (sentient)
- Size: 9 ft. (2.74 m)
- Offensive Capabilities: Blaze Claws, speed, strength
- Defensive Capabilities: Moderate armor

PROFILE

The Earth has cooled considerably in the last hundred years, so a great percentage of the population now lives in cold climates. The Adverse Weather Commando (AWC) is a highly specialized support robot, developed to work in cold-weather environments, usually embedded in other units to assist in accessing targets. It is equipped with Blaze Claws, which electrify and heat up, allowing the AWC to tunnel through ice and snow, as well as anti-gravity rockets, which allow it to fly over difficult terrain.

PLASMA FUEL CELL

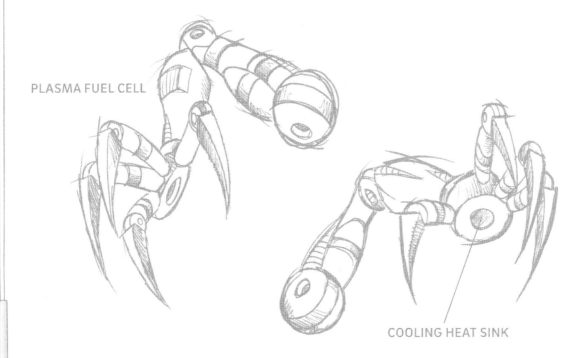

COOLING HEAT SINK

▲ AWC ARMS WITH BLAZE CLAWS *(above)*

Blaze Claws are a powerful alien tech the UEE adapted for use by many of its robots. Blaze Claws, like Blaze Swords, are powered by a plasma fuel cell that heats the metal to different temperatures for cutting through a variety of substances, including metal, rock, and ice. Each claw is equipped with a heat sink which prevents the metal from melting and allows for faster cool-down after use.

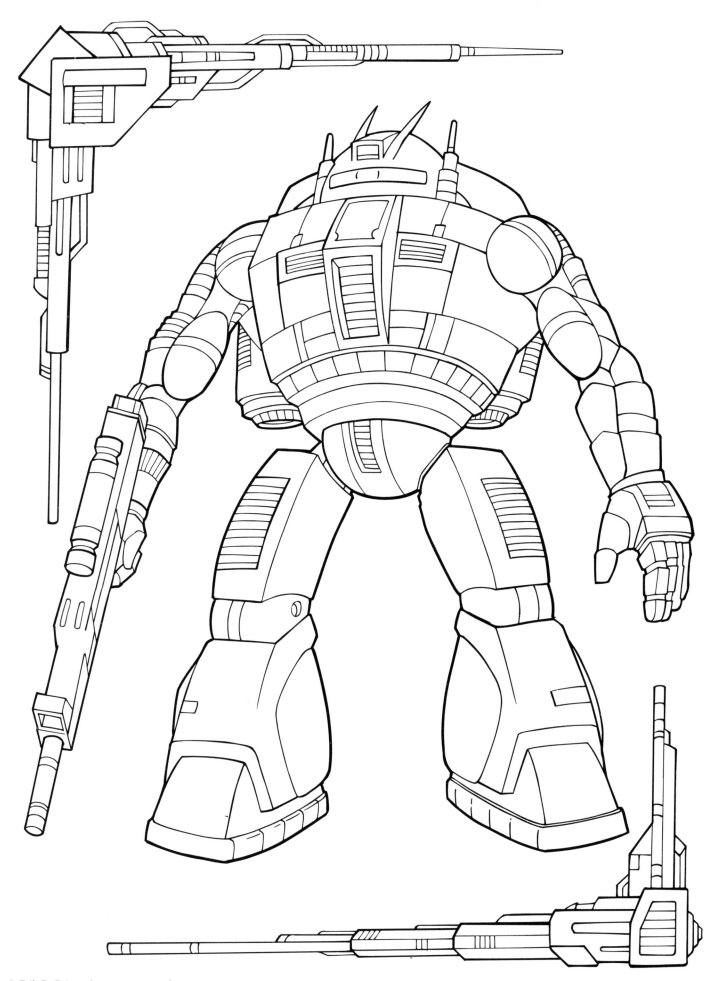

STATS

- Robotic Class: Mechanical (non-sentient)
- Size: 18 ft. (5.49 m)
- Offensive Capabilities: Pulse Rifle
- Defensive Capabilities: Super heavy armor

PROFILE

Preprogrammed to carry out specific tasks, the Anti-Mech and Vehicle Unit (AMV) is an incredibly heavily-armored giant. Known as "The Mech Buster," the AMV specializes in the destruction of heavily armored vehicles and mechs using its powerful Pulse Rifle.

LASER X-RAY SCOPE

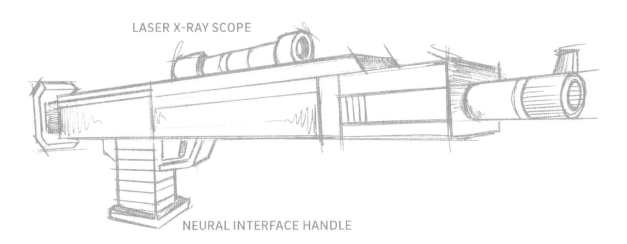

NEURAL INTERFACE HANDLE

▲ PULSE RIFLE *(above)*

The Pulse Rifle, capable of penetrating all physical armor with a high-density charge, was developed by the UEE using sub-light alien technology. Its shots can break through the equivalent of 10 ft. (3 m) of steel.

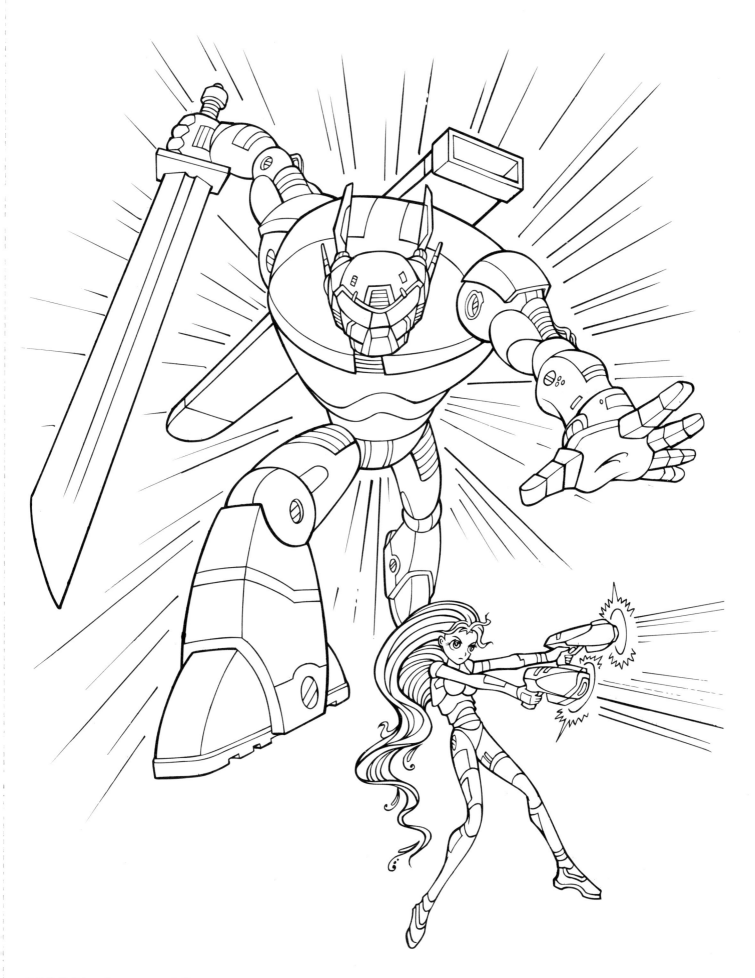

STATS

JENNICON
- Robotic Class: AI (sentient)
- Size: 11 ft. (3.35 m)
- Offensive Capabilities: Blaze Sword
- Defensive Capabilities: Heavy armor

SIMKI
- Robotic Class: Cyborg, human-born (sentient)
- Size: 5.75 ft. (1.75 m)
- Offensive Capabilities: Martial arts and hand weapons
- Defensive Capabilities: Super-strong alien arachnid-silk armor

PROFILES

Jennicon and Simki are a Negotiation Team specialized for urban settings. Jennicon wields a large Blaze Sword and specializes in close combat. Simki is augmented with both Earth and alien tech, including ocular implants that allow her to see through multiple layers of walls—which comes in handy in city settings. She also has regenerating nanobots inside her, making her more machine-like than most human-born cyborgs.

LASER X-RAY SCOPE

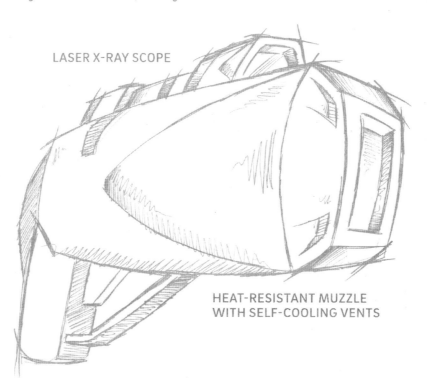

HEAT-RESISTANT MUZZLE
WITH SELF-COOLING VENTS

▲ SIMKI'S PHASE CANNON BLASTER *(above)*

Simki's Phase Cannon Blaster shoots out invisible bursts of energy that target and damage organic tissue. Depending on the blaster's setting, the bursts can pass through many kinds of objects, such as walls and doors, harming only organic tissue and leaving the structures undamaged.

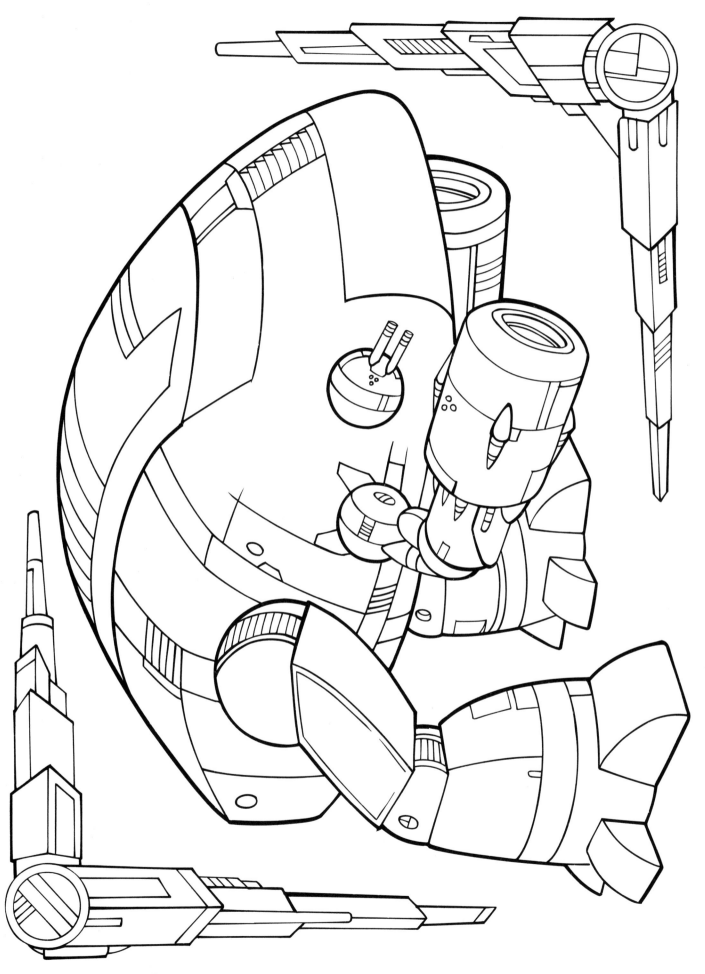

STATS

- Robotic Class: Pilotable Mech (non-sentient)
- Size: 20 ft. (6.1 m)
- Offensive Capabilities: Pulse Rifle
- Defensive Capabilities: Super heavy armor

PROFILE

Utilizing two pilots, the Artillery Siege Mech (ASM) specializes in long-distance bombardment by using its cannons to neutralize opposing land forces and bunkers. The body of the ASM is one of the oldest mech designs currently in use on Earth. As one of the original mechs used by Earth's military prior to the arrival of incomers, it has no shields and no mode of transport besides walking. Developed prior to Earth's acquisition of various alien tech used in UEE's newer robots, it was originally solar powered, but has since been upgraded with a fusion power source. The ASM is still in use because it is a particularly effective troop, is simple to fix, and requires very little training to pilot.

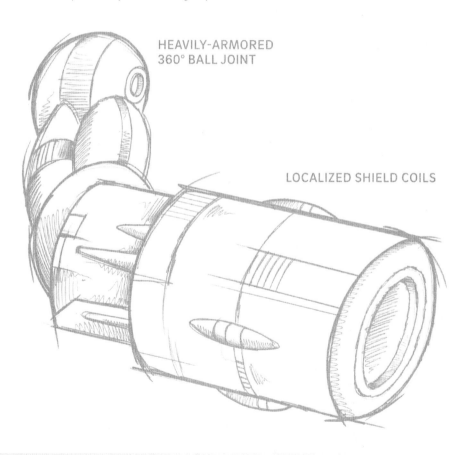

HEAVILY-ARMORED
360° BALL JOINT

LOCALIZED SHIELD COILS

▲ PLASMA FUSION CANNONS *(above)*

The ASM's Plasma Fusion Cannons are alien tech added to the ASM by the UEE. The powerful arm-mounted cannons can be used to take out low-orbit ships, such as drop ships, gun ships, and transport vessels scouting for invasion. Since the cannons are often targeted in attacks, each one is protected by a localized shield generated from coils mounted around the barrel.

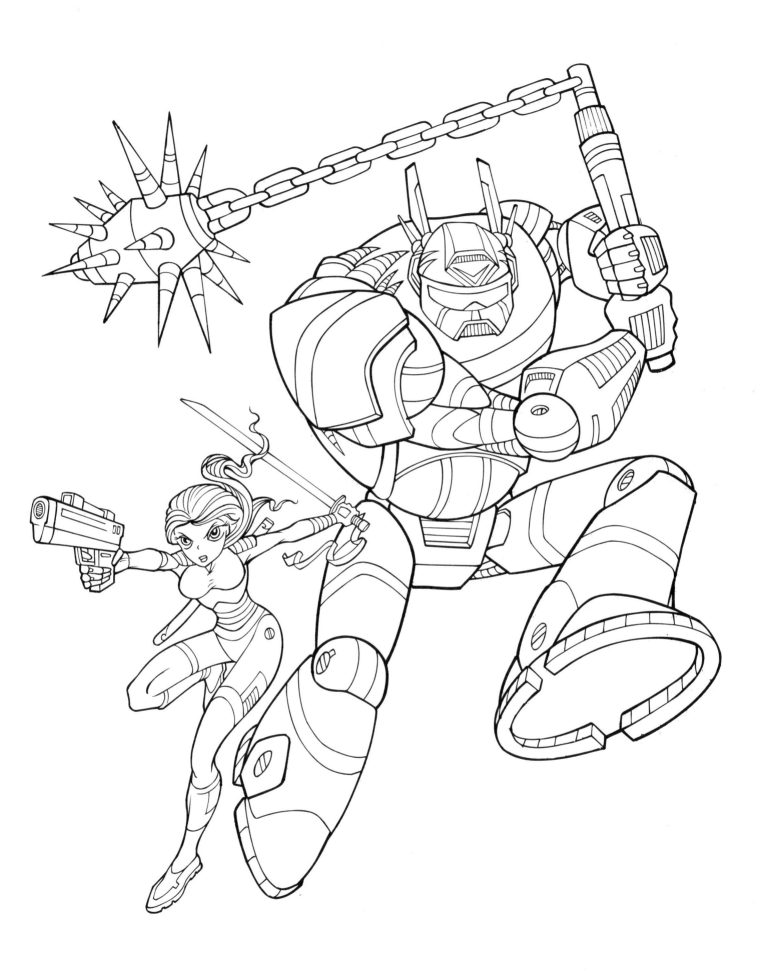

STATS

WARSTAR
- Robotic Class: AI (sentient)
- Size: 8 ft. (2.44 m)
- Offensive Capabilities: Close combat
- Defensive Capabilities: Super heavy armor

ASHIAN
- Robotic Class: Cyborg, mechanical with organic augmentations (sentient)
- Size: 5.25 ft. (1.6 m)
- Offensive Capabilities: Martial arts
- Defensive Capabilities: Super-strong alien arachnid-silk armor

PROFILE

Before Warstar was rescued by Ashian and became part of a UEE Negotiation Team, he was held prisoner and forced to participate in illegal robot pit-fighting. Sentient robots are prohibited from gladiatorial-style combat for sport, but many underground organizations ignore this law, capturing sentient robots and forcing them to fight. Warstar's prior fame as a fighting robot is well known in the criminal underworld, as is his hatred for the pits. Many of the criminals he and Ashian pursue even bet on him in his fighting days—and would never bet against him now. Unlike other Negotiation Teams, Warstar and Ashian are independent bounty hunters, meaning that they work with the UEE, not for the UEE. They're known for taking things into their own hands and not always following the rules, but they are always careful to use non-lethal force so they can deliver their targets alive.

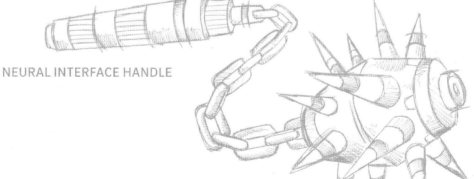

NEURAL INTERFACE HANDLE

MASS CONVERTER
POWER COIL

▲ WARSTAR *(above)*

Warstars are Warstar's weapon of choice and earned him his name in the fighting pits. Originally brought to Earth by alien incomers, Warstars are super dense, electrified maces powered by an internal plasma cell. Weighing about 660 lb. (300 kg), Warstars are used primarily by only the largest and strongest robots. Inside each Warstar is a mass converter power coil that, when activated, can double the Warstar's weight by sending a surge of energy into the coil.

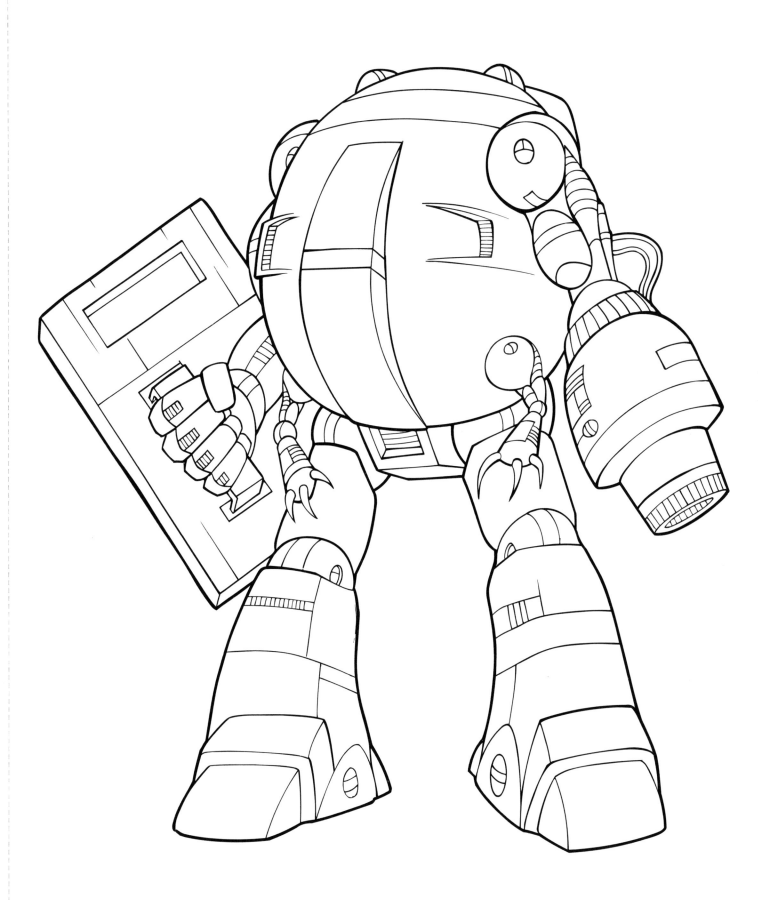

◀ **SUBTERRANEAN SIEGE MECH** *(previous page)*

STATS

- Robotic Class: Pilotable Mech (non-sentient)
- Size: 25 ft. (7.62 m)
- Offensive Capabilities: Fusion Melting Cannon
- Defensive Capabilities: Heavy armor with heat shielding

PROFILE

Utilizing two pilots, the Subterranean Siege Mech (SSM) is specifically designed to tunnel long distances through rock in order to access underground bunkers, including illegal cloning laboratories. Rock in front of the SSM is vaporized using its Fusion Melting Cannon, creating a clear path for troops. Though it appears to be metal, the SSM is actually made of a rare alien arachnid-silk known for its strength and heat-protection properties, which is woven together with carbon fibers.

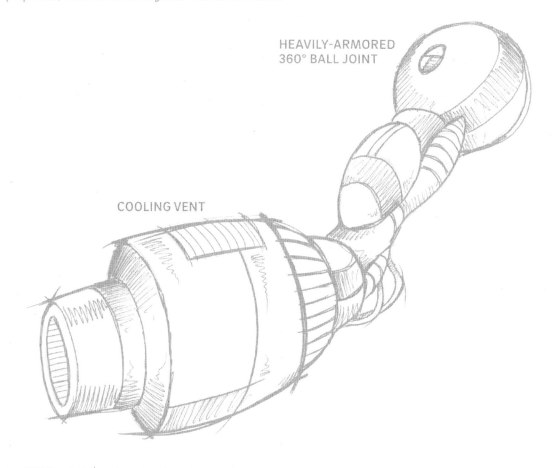

HEAVILY-ARMORED
360° BALL JOINT

COOLING VENT

▲ **FUSION MELTING CANNON** *(above)*

The arm-mounted Fusion Melting Cannon generates a beam so hot it is capable of vaporizing virtually any material. Its beam can be adjusted to destroy rock or any type of metal, and on its highest setting, it can even vaporize certain alien metals considered indestructible on many worlds.

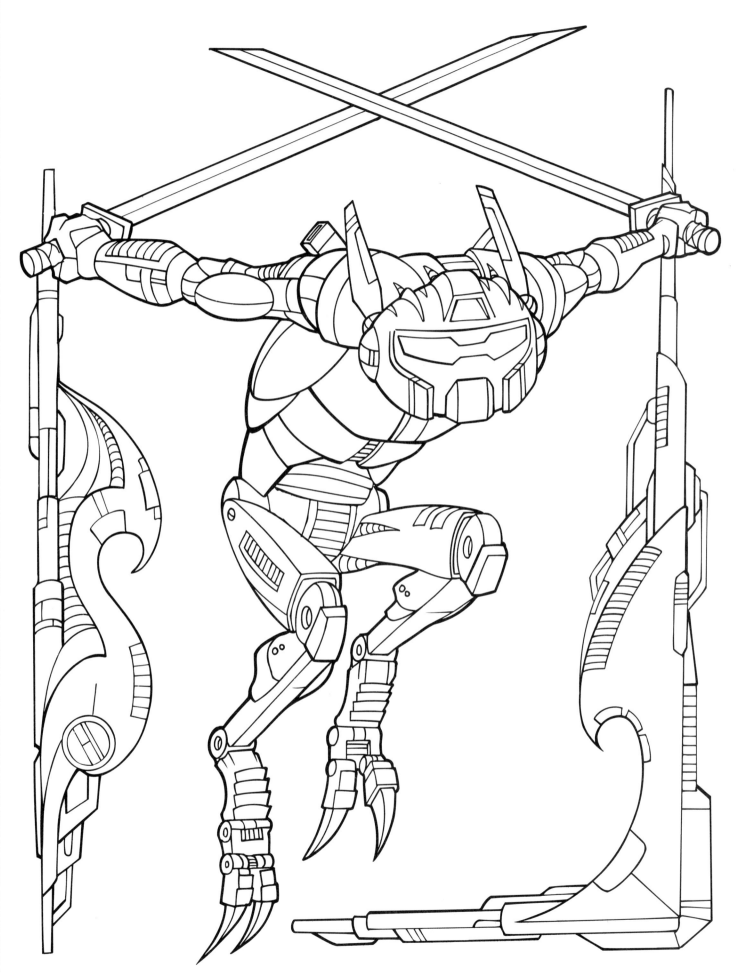

STATS

- Robotic Class: AI (sentient)
- Size: 6 ft. (1.83 m)
- Offensive Capabilities: Blade weapons and speed
- Defensive Capabilities: Moderate armor

PROFILE

The Urban Assault Unit Leader (UAUL) leads raids on criminal organizations. UAULs act as part of the UEE's non-specialized police force for the general population, typically going after local crime groups. They are highly respected as leaders who are active in the field with their units. Other Urban Assault Units report to the UAUL, who reports to UEE Command. UAULs are known for their dangerous proficiency in hand-to-hand combat and skill with blades.

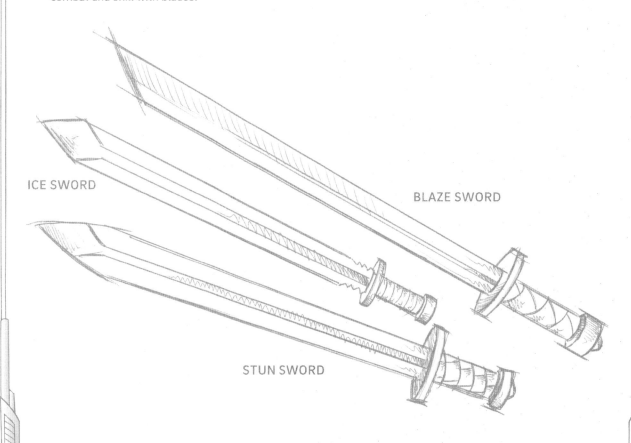

ICE SWORD

BLAZE SWORD

STUN SWORD

▲ VARIOUS SWORDS *(above)*

Urban Assault Unit Leaders use an assortment of specialized blades for different purposes, including Blaze Swords, Stun Swords, and Ice Swords.

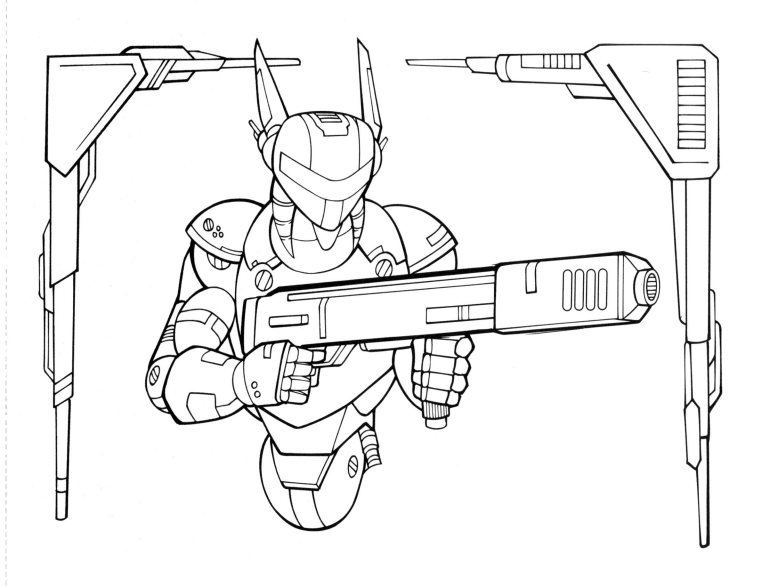

Draw the Lancer's legs.

STATS

- Robotic Class: Mechanical (non-sentient)
- Size: 40 ft. (12.19 m)
- Offensive Capabilities: Beam Cannon
- Defensive Capabilities: Heavy armor

PROFILES

The Lancer is an extremely tall anti-tank military unit specifically used on the battlefield. Its long, agile legs allow it to quickly and precisely move between other ground assault units, such as tanks and troops, during combat. There are many off-world aliens who want to buy, or trade for, Earth robots—occasionally they even attempt to steal them—and this is the only one the UEE is willing to sell to buyers off-world. The export of Lancers brings in a sizable income for the UEE, which is then poured into new robot research programs.

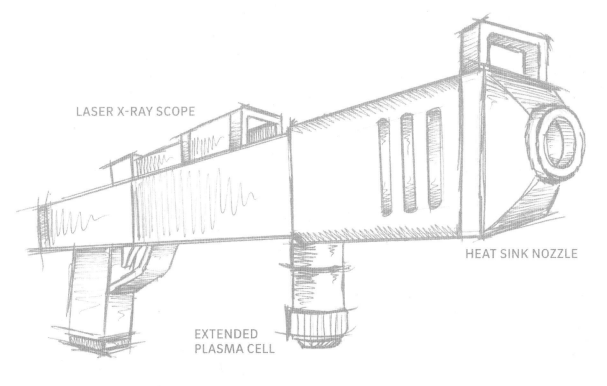

LASER X-RAY SCOPE

HEAT SINK NOZZLE

EXTENDED
PLASMA CELL

▲ BEAM CANNON *(above)*

The Lancer's Beam Cannon works much like a laser. It shoots a constant beam of energy that pierces hulls and armor, which is particularly effective for disabling armored vehicles and ships.

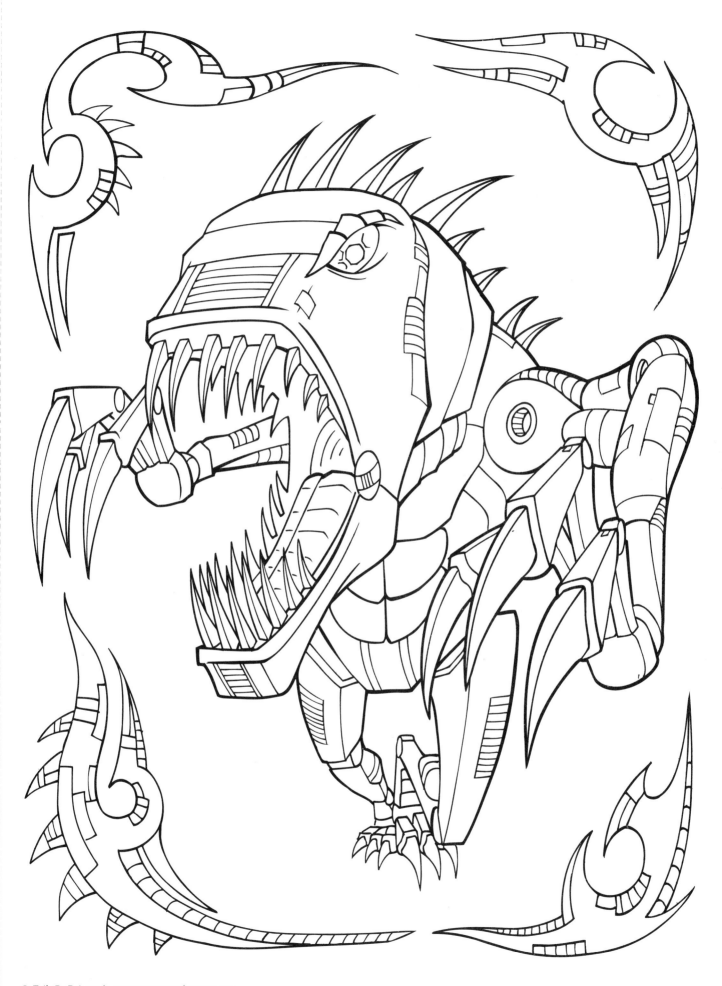

STATS

- Robotic Class: Mechanical (non-sentient)
- Size: 4–12 ft. (1.22–3.66 m)
- Offensive Capabilities: Vicious ripping claws and jaws
- Defensive Capabilities: Durable unit with moderate armor

PROFILE

Ravengers are preprogrammed robots that are illegal to use on the Earth's surface because of their extremely destructive behaviors. However, that does not stop the UEE from using these vicious robots *off* of the Earth's surface. (Nor does it stop criminals from importing Ravengers to use illegally as guard dogs.) There are many Ravenger variations, and their size can range from that of a large dog to a rhinoceros. When Earth is dealing with an orbital threat, such as a spacecraft with demands or an imminent invasion of some kind, Ravengers are teleported onto the enemy ships. They then destroy anyone or anything on board that is identified as a potential threat, leaving the ship mostly intact and its technology salvageable. Before the Ravengers, the UEE would teleport explosives onto ships, but in several instances this resulted in disabled ships falling into a decaying orbit and crashing back to Earth.

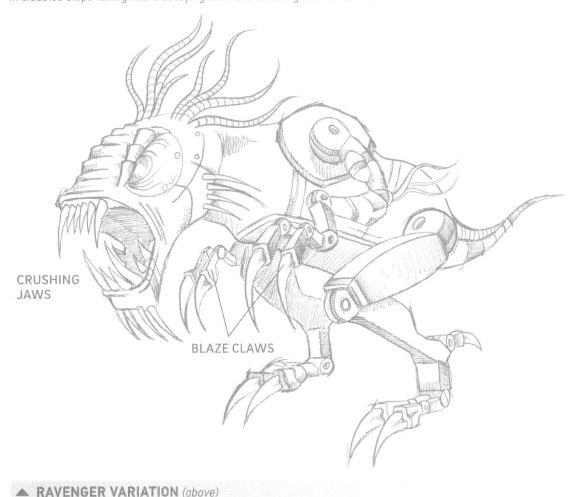

CRUSHING
JAWS

BLAZE CLAWS

▲ **RAVENGER VARIATION** *(above)*

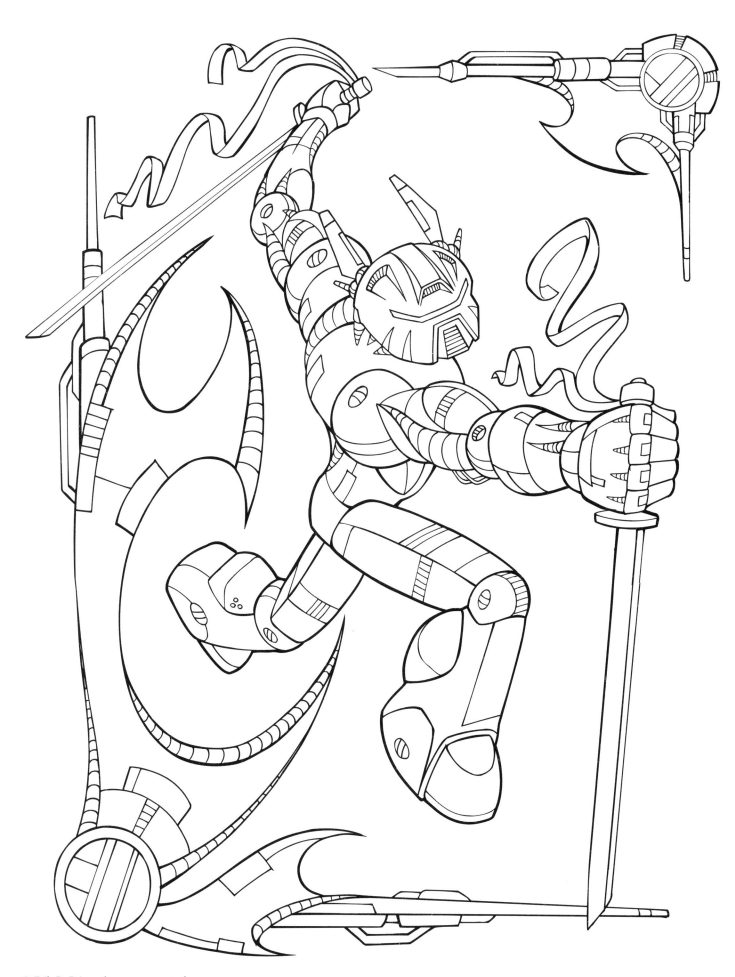

STATS

- Robotic Class: Cyborg, human-born (sentient)
- Size: 7 ft. (2.13 m)
- Offensive Capabilities: Intelligence, strategic planning, hand-to-hand combat
- Defensive Capabilities: Moderate armor

PROFILE

The UEE functions as both an Earth police force and a domestic army. Kente serves as the highest-level commander in his role as Strategic Commander of all UEE forces. He is a fighting leader, personally involved on the ground in many of the UEE's most important missions, and also acts as the foremost professor of hand-to-hand combat at the UEE Academy. When incomers first arrived on Earth, Kente was a brilliant and decorated military officer. He was badly injured in a battle, leaving him crippled for years before alien technology could successfully augment humans with cybernetic implants. Becoming a cyborg was never really a choice for Kente; it was the only way he could ever have a life again. As a cyborg he is now mostly machine, except for his brain, which is still very much the same brilliant mind it always was.

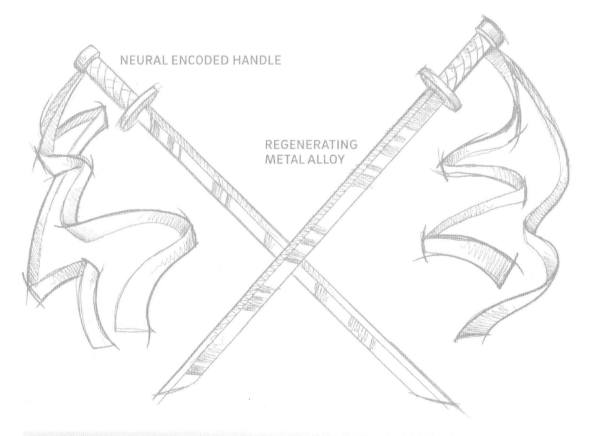

NEURAL ENCODED HANDLE

REGENERATING
METAL ALLOY

▲ **KENTE'S BLAZE SWORDS** *(above)*

Kente developed the Blaze Swords as his own unique weapon. They are electrified and can shoot out a burst of electricity. The UEE was so impressed with Kente's Blaze Swords that they decided to make a military version (removing the burst of electricity, which they felt was too unpredictable) for other robots, such as the Royal Guard.

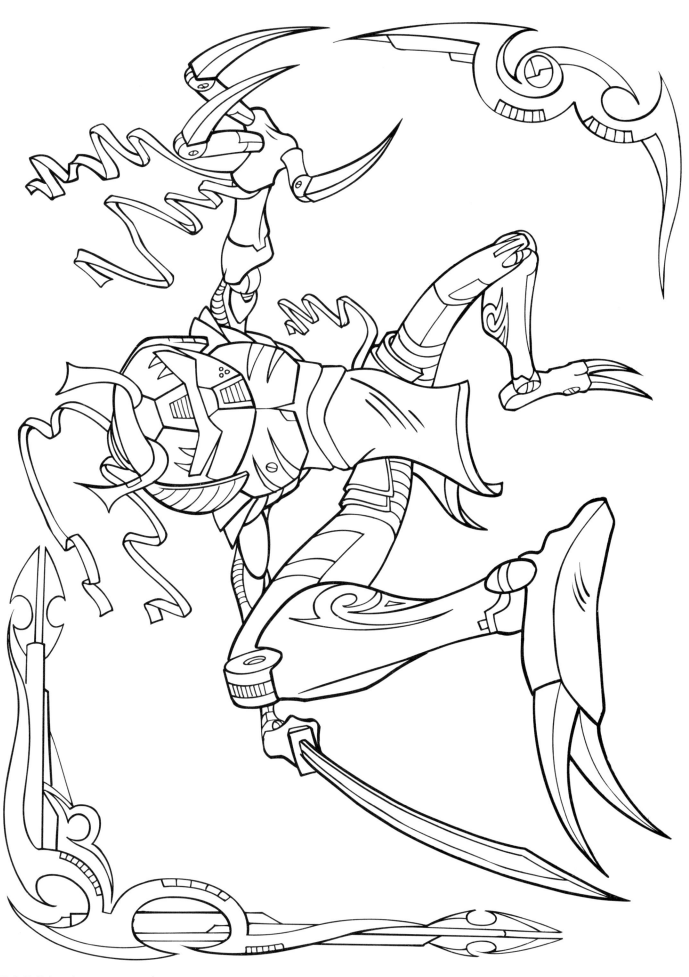

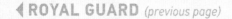

◀ ROYAL GUARD *(previous page)*

STATS

- Robotic Class: AI (sentient)
- Size: 6.5–7.5 ft. (1.98–2.29 m)
- Offensive Capabilities: Highly skilled at hand-to-hand combat, very fast
- Defensive Capabilities: Light armor, extreme speed and agility

PROFILE

The Royal Guard are personal security bodyguards employed by high level UEE officials and other diplomats or visitors to Earth seeking around-the-clock protection. Members of the Royal Guard are an elite and loyal group, willing to sacrifice their lives for the protection of their clients. It is customary for members of the Royal Guard to be ornately decorated with elaborate helmets, shoulder pads, and other accouterments of their choosing, and they are generally decorated in colors that represent the world region where they were originally created. Appearing stoic in public, Royal Guards are actually quite personable with their clients when in private. Clients often consult them for their highly logical advice and opinions, and officials and business people regard them as the ultimate secret-keepers.

PLASMA FUEL CELL

REGENERATING METAL ALLOY

NEURAL ENCODED HANDLE

▲ BLAZE SWORD *(above)*

The Royal Guard's Blaze Swords have a plasma fuel cell in the handle, which heats up and electrifies the sword so that it electrocutes whatever it hits with 500,000 volts.

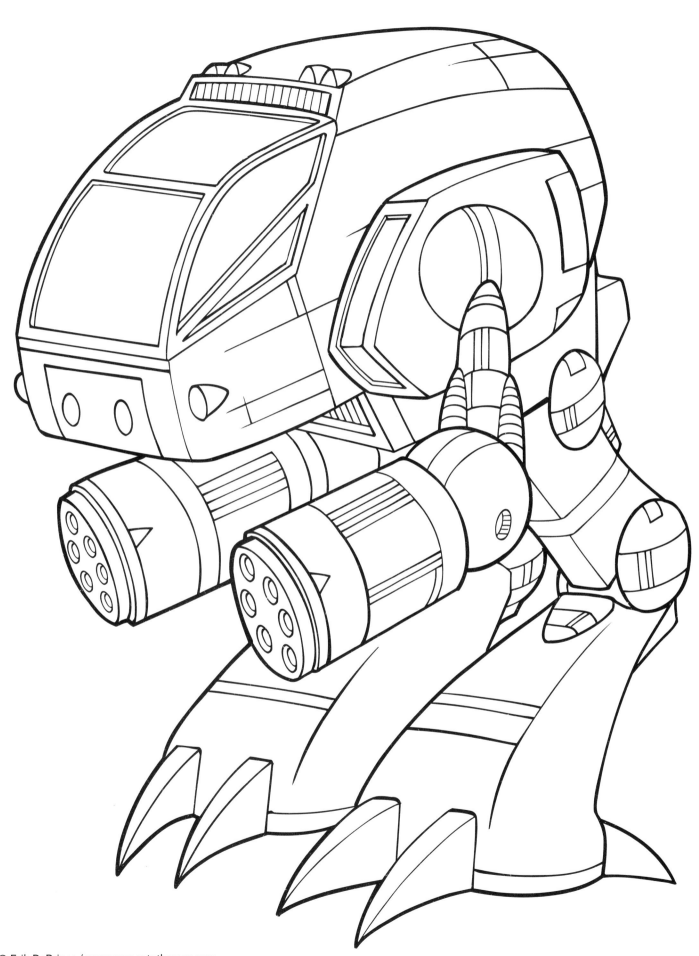

◀ DISASTER RECON MECH *(previous page)*

STATS

- Robotic Class: Pilotable Mech (non-sentient)
- Size: 9 ft. (2.74 m)
- Offensive Capabilities: Plasma Torpedoes
- Defensive Capabilities: Light armor, strong energy shield, heat shielding

PROFILE

Though the UEE's robots are tough and strong, each represents a huge financial investment, so the UEE is always very cautious about sending robots into extremely hazardous areas. It's also especially important to maintain safe working environments for AI robots who, under Earth's Entity Equality Rights laws, are protected by the same laws and rights of safety as non-robotic entities. So when a disaster or explosion occurs, the UEE sends in the Disaster Recon Mech (DRM) to assess and secure areas before sending in additional forces. Designed for hazardous environments and situations, such as active battlefields, burning cities, high radiation levels, explosions, and natural disasters, the DRM is built to resist heat, extreme dust, ash, acid, and just about any other threat. The DRM has several different types of shielding, including a strong energy shield to repel radiation, heat, and projectiles, and shielding to protect against electromagnetic pulses. The DRM's single pilot also controls several Disaster Recon Drones, which can be deployed to further investigate an area and report back to UEE Command.

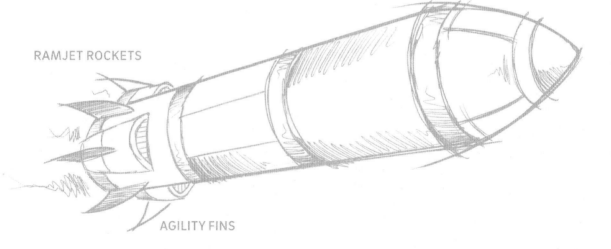

RAMJET ROCKETS

AGILITY FINS

▲ PLASMA TORPEDOES *(above)*

The DRM's Plasma Torpedoes are encased in lightly armored insulated cartridges, helping them to withstand extreme heat, cold, and other adverse environmental conditions.

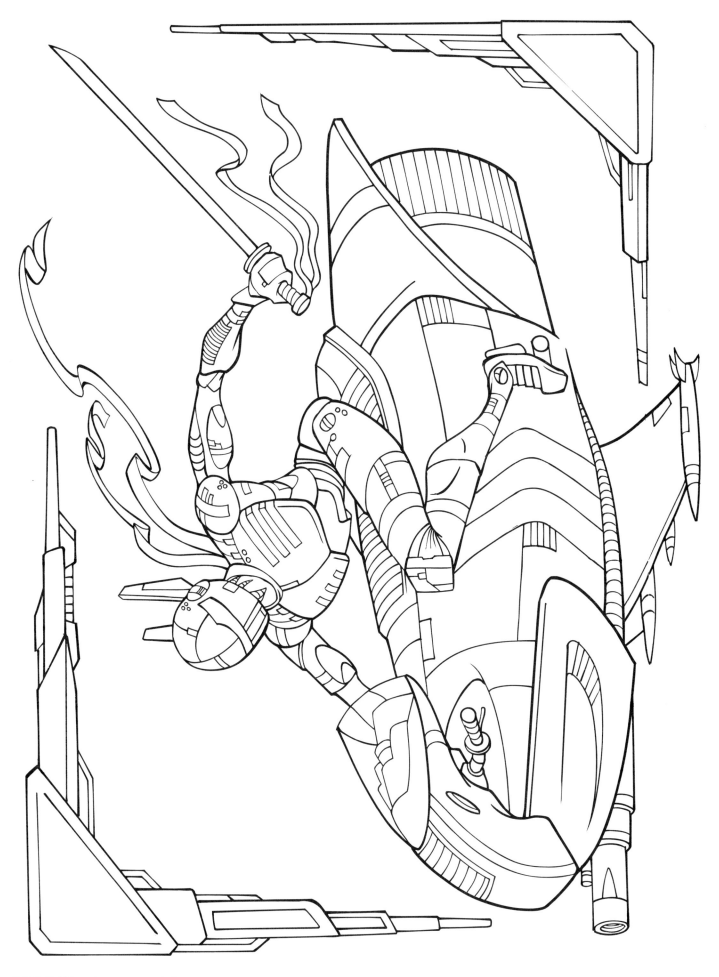

STATS

- Robotic Class: Cyborg, robot-created with human augmentations (sentient)
- Size: 6 ft. (1.83 m)
- Offensive Capabilities: Particle Beam
- Defensive Capabilities: Light armor, speed

PROFILES

With Earth much more crowded because of the influx of off-world incomers, it is essential to use space efficiently. Incomers from aerial worlds were quick to begin building upward, constructing floating land cities and structures far taller than anything humans could have imagined creating. With so many making their homes high above the ground, a police force specially adapted to life in the sky was needed. The UEE developed the Skyway Rangers, organically enhanced cyborgs commonly referred to as Sky Cops. The Rangers mainly work alone in designated territories, stationed out of UEE satellite offices on the floating cities. Rangers' lightweight carbon Hypersonic Bikes are basically ramjet engines with a steering system; they allow the Rangers to pursue targets in low or high altitudes. It is the goal of the Skyway Rangers to be as friendly with the community as possible, while also enforcing order and justice.

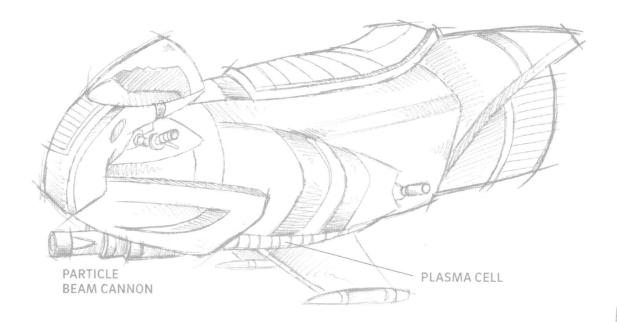

PARTICLE
BEAM CANNON

PLASMA CELL

▲ **HYPERSONIC BIKE WITH PARTICLE BEAM** *(above)*

The Skyway Ranger's Hypersonic Bike has an adjustable energy particle beam that can disable vehicles without destroying them. The bike has a dampening field to minimize the effect of the g-forces the driver experiences, as well as a shield to protect the rider from being hit or falling off.

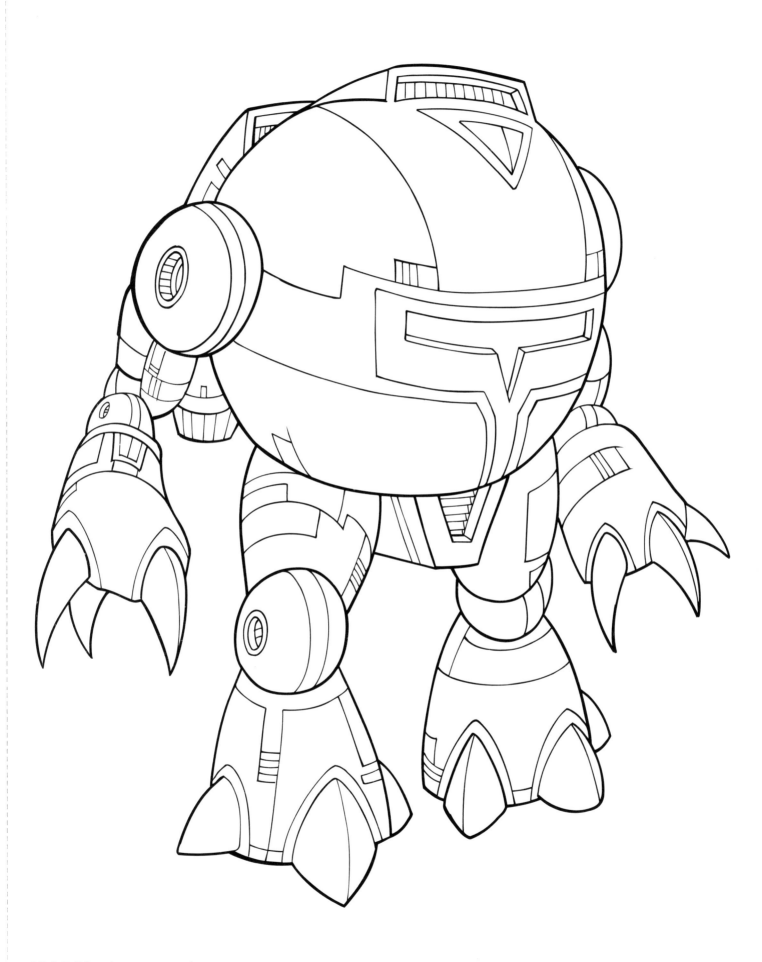

STATS

- Robotic Class: Pilotable Mech (non-sentient)
- Size: 10 ft. (3.05 m)
- Offensive Capabilities: Strength, Ripper Claws
- Defensive Capabilities: Heavy armor, stable environment shielding

PROFILE

Versatile and able to withstand a ton of damage, the Brute is the UEE's most advanced and dynamic mech. While most mechs are limited to the planet's surface in order to keep the pilot safe, the Brute and its single pilot can go anywhere. Using advanced alien shielding to maintain a stable environment for the pilot, the Brute is able to traverse any landscape from the ocean floor to the vacuum of space and everything in between. The Brute is equipped with vicious spinning Ripper Claws, designed to go through the heaviest armor, as well as a rocket pack that directs flight in the air and propulsion in the water.

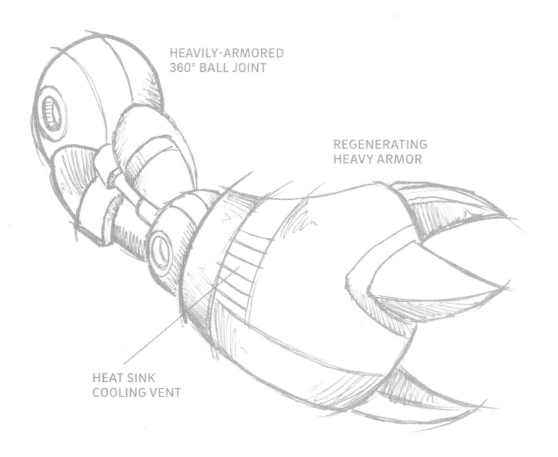

HEAVILY-ARMORED
360° BALL JOINT

REGENERATING
HEAVY ARMOR

HEAT SINK
COOLING VENT

▲ RIPPER CLAWS (above)

The Brute's Ripper Claws are both useful tools and dangerous weapons. Spinning at 1,000 rpm, the stout and thick claws can easily penetrate the heaviest armor and quickly tunnel through rock and ice.

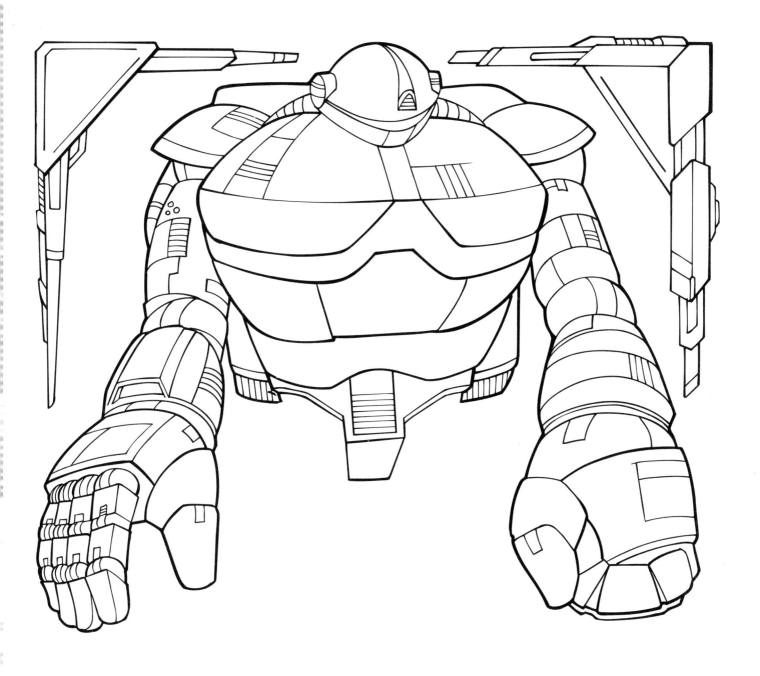

Draw the Pulverizer's legs.

STATS

- Robotic Class: Mechanical (non-sentient)
- Size: 8–10 ft. (2.44–3.05 m)
- Offensive Capabilities: Strength, smashing with Concussive Fists
- Defensive Capabilities: Super heavy armor

PROFILE

One of Earth's original robot defenders, the Pulverizer is known for its brute strength. Designed to take out buildings and vaults in situations where explosives would be too destructive, this simple, lumbering machine is an expert at breaking things with its giant, powerful hands. Pulverizers are mass-produced and available in a range of sizes and strengths.

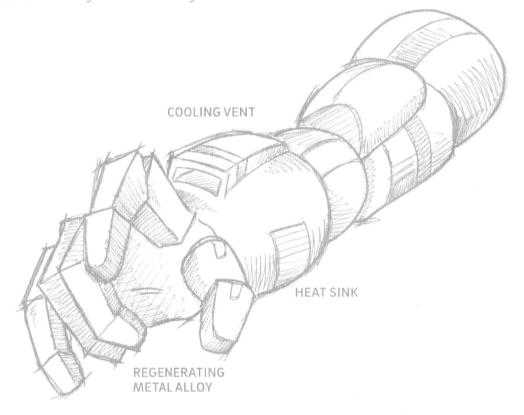

COOLING VENT

HEAT SINK

REGENERATING
METAL ALLOY

▲ **CONCUSSIVE FISTS** *(above)*

When the Pulverizer's giant concussive fists slam into something, they create a shockwave that can crumble rock and concrete, perfect for demolishing structures, walls, and bunkers.

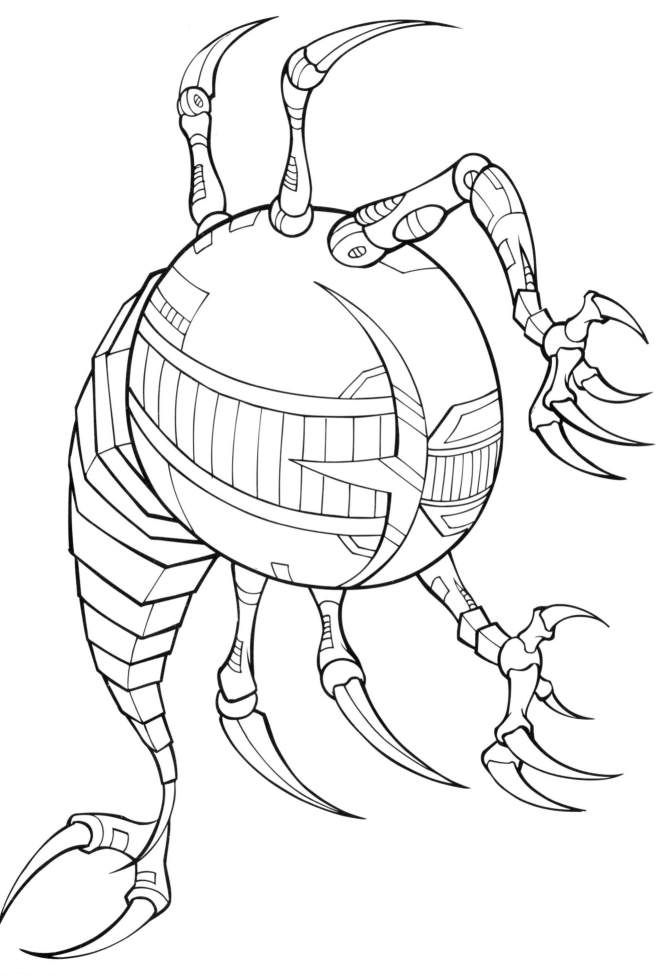

STATS

- Robotic Class: Mechanical (non-sentient)
- Length: 0.000000039 in. (1 nanometer)
- Offensive Capabilities: Able to reprogram other robots, sabotage hardware
- Defensive Capabilities: Electromagnetic pulse (EMP) protection

PROFILE

Originally nanobots were introduced to Earth as medical healing devices, but the UEE immediately saw their potential as a weapon. In an age when coded viruses have been overused and firewall protection is almost impenetrable, the only sure way to effectively disable or take control of another robot is to physically sabotage them or reconfigure their hardware. And at only one nanometer long, nanobots are the perfect solution, working just as well in organic entities as they do mechanical ones. Once inside another robot or human host, nanobots are programmed to attack specific hardware or cells, either hijacking a host, disabling it, or reprogramming it. Neural Nanobots are a class of nanobots specifically designed to override the control center of a host to force it to carry out new orders.

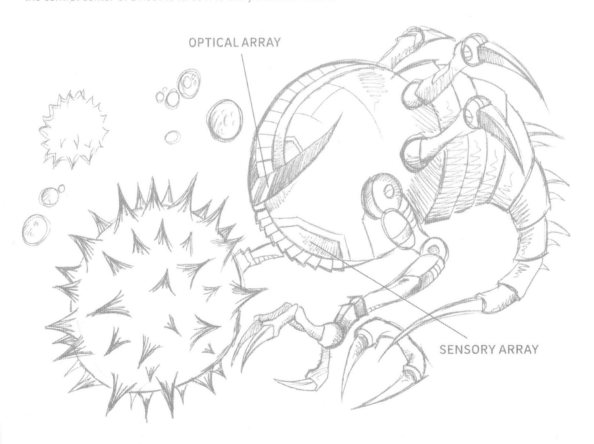

OPTICAL ARRAY

SENSORY ARRAY

▲ **MAGNIFIED CLOSE-UP OF NANOBOT ATTACKING A CELL** *(above)*

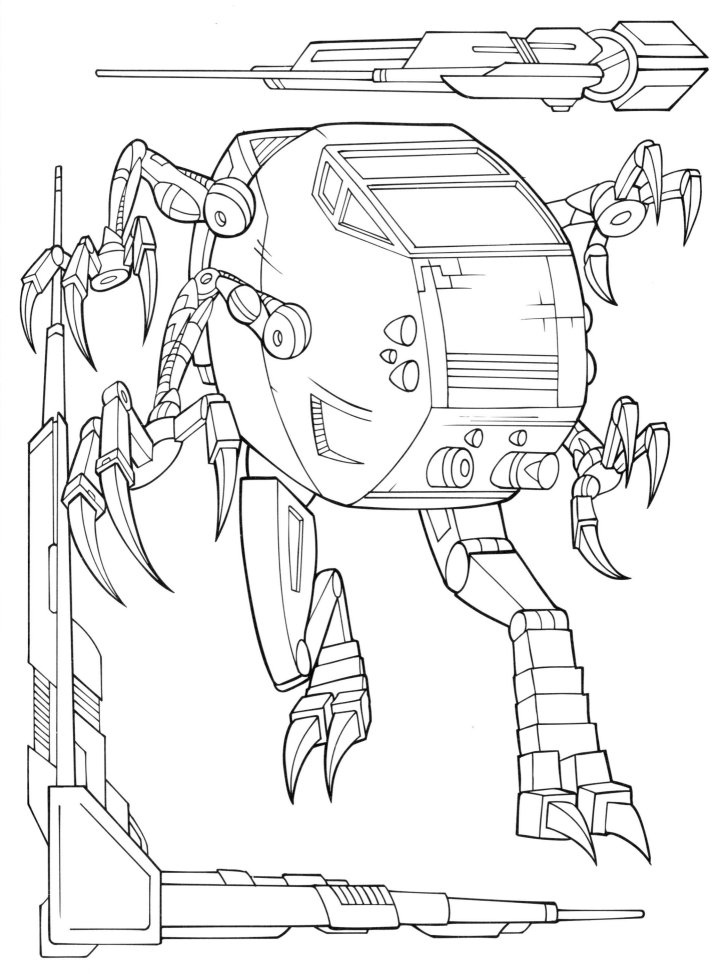

STATS

- Robotic Class: Mechanical (non-sentient)
- Size: 10 ft. (3.05 m)
- Offensive Capabilities: Strength, smashing
- Defensive Capabilities: Super heavy armor

PROFILE

The Street Runner is a mech designed specifically for criminal pursuit in populated areas. With the Earth so crowded, the UEE is very sensitive about keeping projectile weapons out of the hands of any robots that patrol the streets. It would be too easy to accidentally shoot the wrong individual during a pursuit. The Street Runner is quick and precise, able to nimbly maneuver through crowds to disable and capture its target. Outfitted with a powerful Sonic Immobilizer, the Street Runner uses different frequencies and pulses of sound to disable members of any race, alien or human.

AIR INTAKE

VIBRATION-RESISTANT METAL ALLOY

▲ SONIC BOOSTER PACK *(above)*

The Sonic Booster Pack is one of the UEE's most versatile transport packs. It uses a fuel-less sonic technology, adapted from alien tech, which allows for motion through a variety of environments, such as water, air, and space, with no distance restrictions.

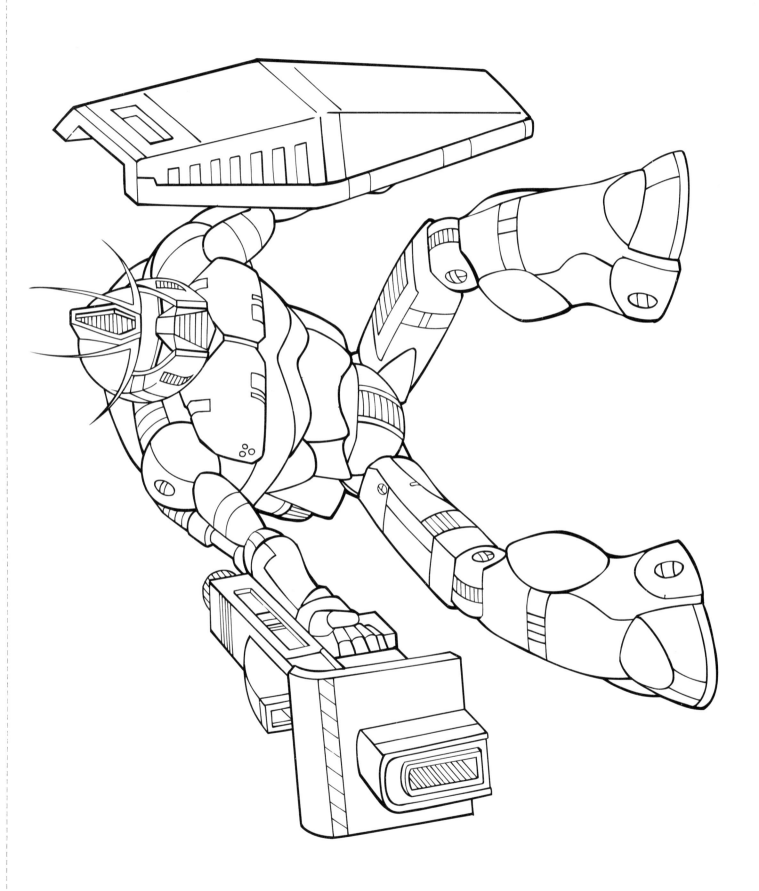

STATS

- Robotic Class: AI (sentient)
- Size: 6–7 ft. (1.83–2.13 m)
- Offensive Capabilities: Pulse Stunner with two settings
- Defensive Capabilities: Light armor, anti-blast shield

PROFILE

The Urban Assault Unit (UAU) is one of the main ground units used by the UEE as a non-specialized police force for the general population, in both urban and rural settings. UAUs are lead by Urban Assault Unit Leaders. While it is a sentient AI robot, the UAU does not typically exhibit the independent drive of many other AI units. Preferring to work together in tactical teams, UAUs are lead by Urban Assault Unit Leaders and networked in small groups of 8–16 units. The UAU's ability to function effectively and reliably within the chain of command makes it the preferred choice of human UEE officers for their SWAT teams. All UAUs are equipped with a two-setting stunner and anti-blast shield designed to protect against small arms fire and explosives.

X-RAY SCOPE

ASSAULT SCOPE

ANTI-BLAST SHIELD

▲ PULSE STUNNER (AKA "THE REGULATOR") *(above)*

The UAU's Pulse Stunner generates an electrical pulse that can knock out humans and some robots when used on its stun setting. Robots with EMP protection or shields are not as susceptible to the stun effects. On the second setting, the Stunner discharges a potentially lethal plasma burst. This setting is used rarely and only as a last resort because it takes up a lot of energy and depletes the stunner, rendering it useless until it can be recharged, which leaves the UAU without an offensive weapon.

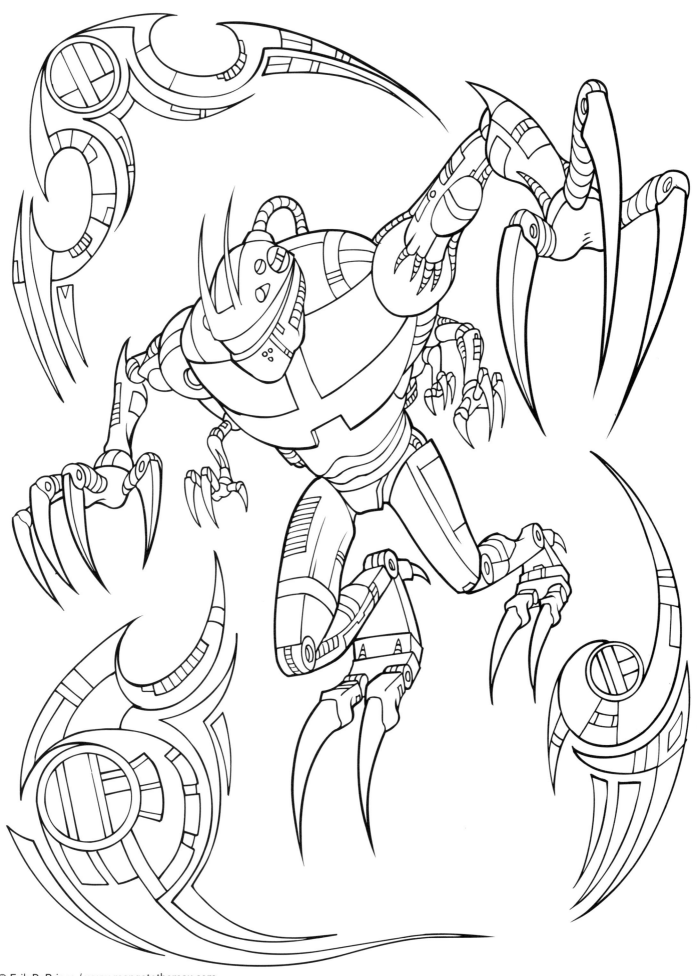

STATS

- Robotic Class: AI (sentient)
- Size: 12 ft. (3.66 m)
- Offensive Capabilities: Disintegrator Claws
- Defensive Capabilities: Heavy armor

PROFILE

The influx of incomers to Earth also brought insect-like alien life, parasites, large-scale bacteria and viruses, and other strange invaders. The UEE refers to these creatures as "unclassified aliens." When Earth faces one of these new and poorly understood threats, action is taken swiftly. An increasing number of very small asteroids have been hitting Earth—some believe purposefully. They carry on them specimens of a specific microscopic alien life form that, once on Earth, rapidly grow into dangerous animal-like creatures. Conventional weapons and projectile weapons have proven ineffective against these creatures, so the UEE created the Exterminator, a warrior with acid-laced Disintegrator Claws that mimics these creatures' close-combat style of fighting.

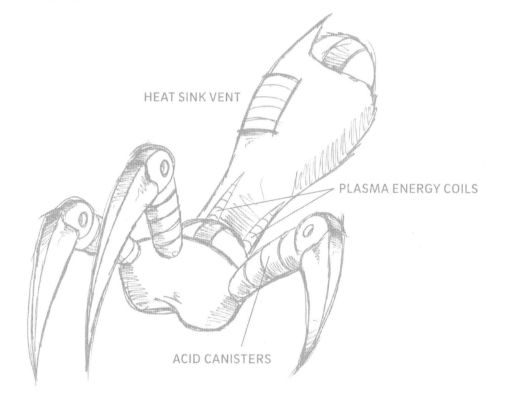

HEAT SINK VENT

PLASMA ENERGY COILS

ACID CANISTERS

▲ DISINTEGRATOR CLAWS *(above)*

Because many unclassified aliens are immune to conventional weapons, including electricity, the Exterminator uses a very special weapon—Disintegrator Claws. Inside the cylindrical base of each claw is a different type of super-concentrated acid, designed to be released at will through tiny holes in the claw's surface. When the Exterminator's claws come into contact with its target, it can control the release of just the right combination of acids to either stun or destroy the target.

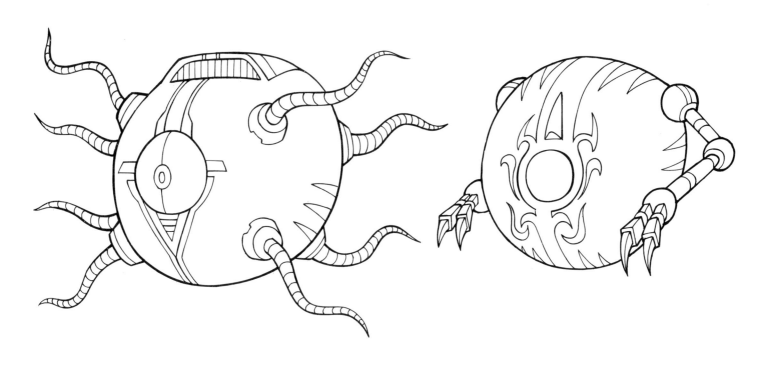

Draw your own UEE drones.

◀ SABOTAGE DRONE *(previous page, left)*

STATS

- Robotic Class: Mechanical (non-sentient)
- Size: 6 ft. (1.83 m) diameter
- Offensive Capabilities: Sabotage, Slashing Tentacles
- Defensive Capabilities: Light armor, cloaking, short-range teleportation

PROFILE

With cloaking abilities and a radar-jamming device, the Sabotage Drone is almost impossible to detect. It has a short-range teleporter, allowing it to jump to locations up to 65 ft. (20 m) from its current position—perfect for popping in and out of buildings or installations. If the drone is ever cornered or captured, it self-destructs.

◀ SPY DRONE *(previous page, right)*

STATS

- Robotic Class: Mechanical (non-sentient)
- Size: 3 ft. (0.91 m) diameter
- Offensive Capabilities: None
- Defensive Capabilities: Cloaking

PROFILE

The Spy Drone is equipped with numerous powerful sensors and recording devices for gathering information, as well as a cloaking device to allow it to move about undetected. It has the ability to teleport up to 65 miles (100 km), but the teleportation coil needs 12 hours to recharge, so the function is only used in emergencies. Like the Sabotage Drone, if a Spy Drone is captured, it self-destructs so the information it has collected does not fall into the wrong hands.

OPTICAL SENSOR ARRAY

◀ THUNDER DRONE *(left)*

STATS

- Robotic Class: Mechanical (non-sentient)
- Size: 12 ft. (3.66 m) diameter
- Offensive Capabilities: Carries two Thunder Missiles
- Defensive Capabilities: Super heavy armor, speed

PROFILE

An offensive military weapon delivery system, each Thunder Drone is used to deliver two Thunder Missiles, specially designed to rupture spaceship hulls, to its target. Thunder Drones are used as a sort of disposable missile delivery system in situations that are too dangerous to use piloted spacecraft.

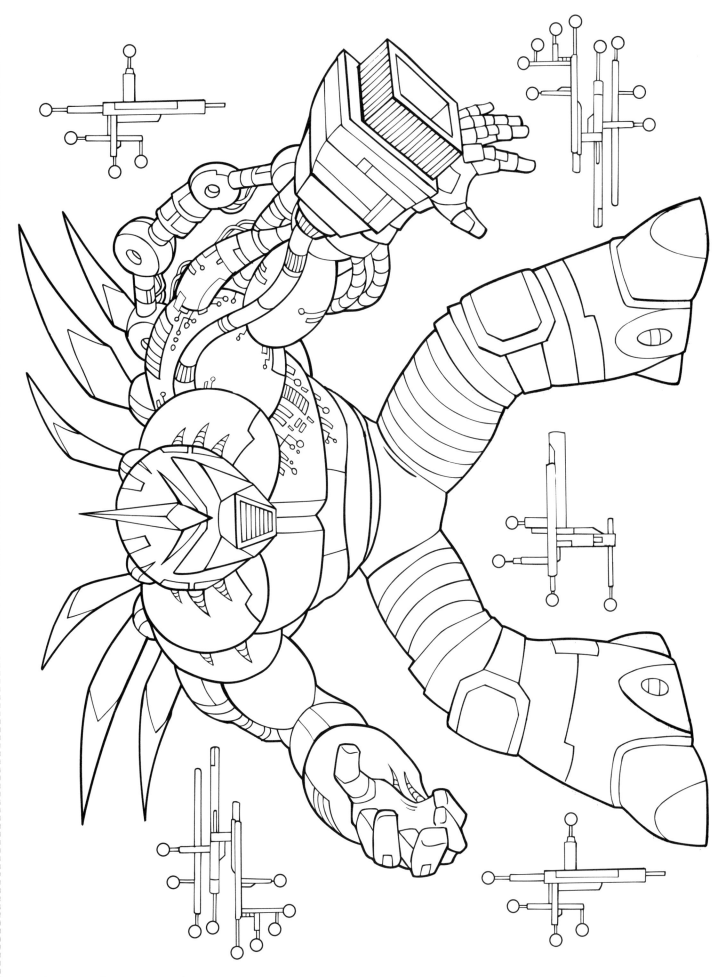

◀ DIGITAL ANNIHILATOR *(previous page)*

STATS

- Robotic Class: AI (sentient)
- Size: 6 ft. (1.83 m)
- Offensive Capabilities: Static Death Cannon
- Defensive Capabilities: Light armor

PROFILE

The Digital Annihilator specializes in disabling, and sometimes taking over, computers and robots. It does this with the Static Death Cannon, a device mounted on its arm that emits a combination EMP pulse and Wi-Fi attack. The Annihilator also specializes in hacking and writing computer viruses. A hardware infiltrator connects the Annihilator directly to computers and some robots, allowing it to rewrite their base coding.

REINFORCED SHOCK
ABSORBING SUPPORT JOINT

HIGH-ENERGY
OUTPUT POWER CABLE

▲ STATIC DEATH CANNON *(above)*

The Static Death Cannon disables robots by shooting out a concentrated EMP pulse combined with a wireless attack. Its super strong Wi-Fi signal can go through armor and shielding, delivering a variety of specialized computer viruses and malware to its target. The cannon's beam also has the ability to reprogram and take over AI, essentially killing them by erasing their individuality, which is what earned it the name "Static Death."

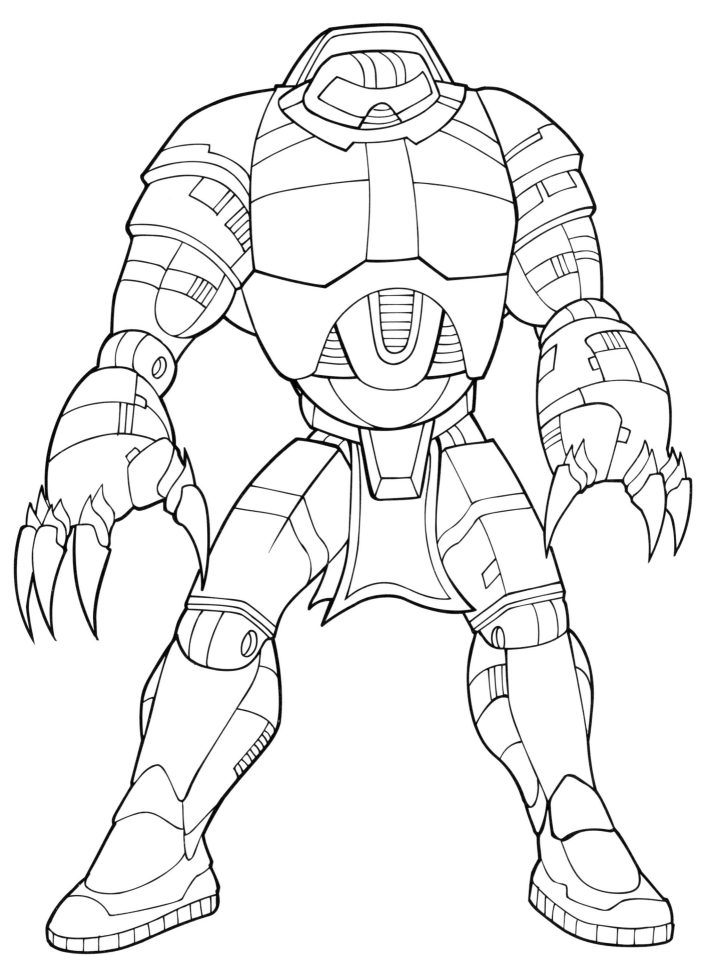

STATS

- Robotic Class: AI (sentient)
- Size: 7 ft. (2.13 m)
- Offensive Capabilities: Non-lethal Stun Claws
- Defensive Capabilities: Moderate armor

PROFILE

Earth frequently hosts alien guests, including political leaders of other worlds and important business figures. The UEE assigns a Bodyguard Unit to all important guests. Incredibly well versed in all types of alien culture as well as hand-to-hand combat, the Bodyguard Unit serves as a knowledgeable guide to Earth's many cultures and locations, while always able to defend its guest if a dangerous situation arises. Known as the most charming and charismatic robots, each Bodyguard Unit's easygoing and humorous nature makes guests feel welcome and safe.

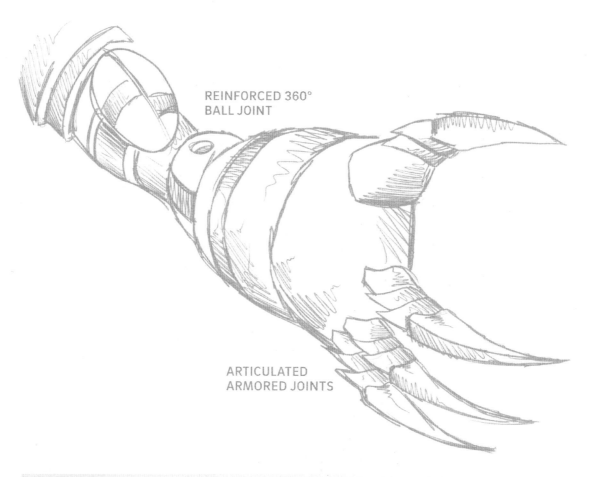

REINFORCED 360°
BALL JOINT

ARTICULATED
ARMORED JOINTS

▲ STUN CLAWS *(above)*

Each Bodyguard Unit is equipped with Stun Claws that deliver a non-lethal jolt of electricity when activated. Unlike some of the other UEE claw designs, Stun Claws have highly articulated armored joints with great mobility and fine motor skills, allowing the Bodyguard Unit to use its claws as fingers for everyday activities.

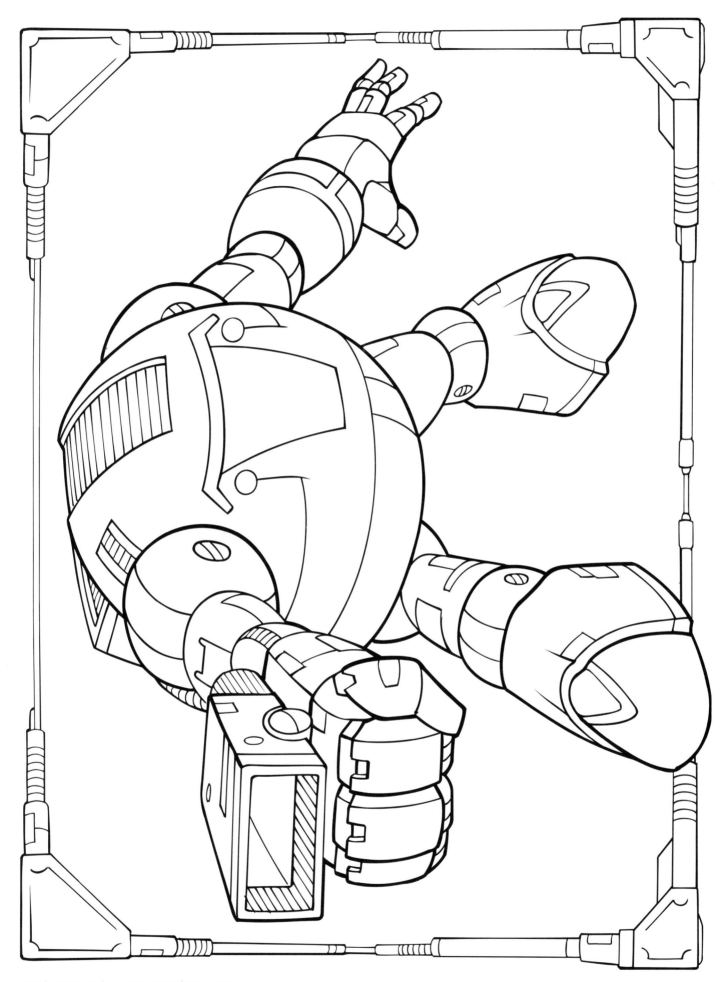

◀ SUBMERSIBLE ASSAULT MECH *(previous page)*

STATS

- Robotic Class: Pilotable Mech (non-sentient)
- Size: 16 ft. (4.88 m)
- Offensive Capabilities: Smashing power, Abyss Cannon
- Defensive Capabilities: Heavy armor able to withstand immense water pressure

PROFILES

Many incomers arrived from ocean planets, drawn to Earth's plentiful water, and now dwell underwater. The Submersible Assault Mech (SAM) specializes in underwater patrols and combat. The SAM and its single pilot police these underwater communities like the Urban Assault Unit does in cities. With its heavy armor, the SAM can withstand immense water pressure, allowing it to safely go as deep as 7 miles (11 km) underwater. A powerful water-jet system propels this mech so it can quickly cover great distances underwater.

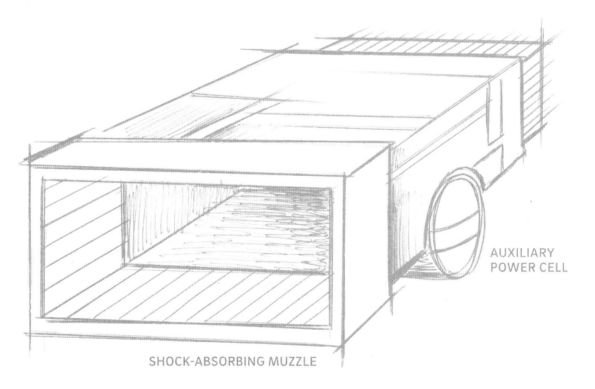

AUXILIARY POWER CELL

SHOCK-ABSORBING MUZZLE

▲ ABYSS CANNON *(above)*

SAMs are equipped with an Abyss Cannon. The cannon generates a shockwave that travels outward at the speed of sound underwater and dissipates with distance, making it ideal for short- to mid-range use.

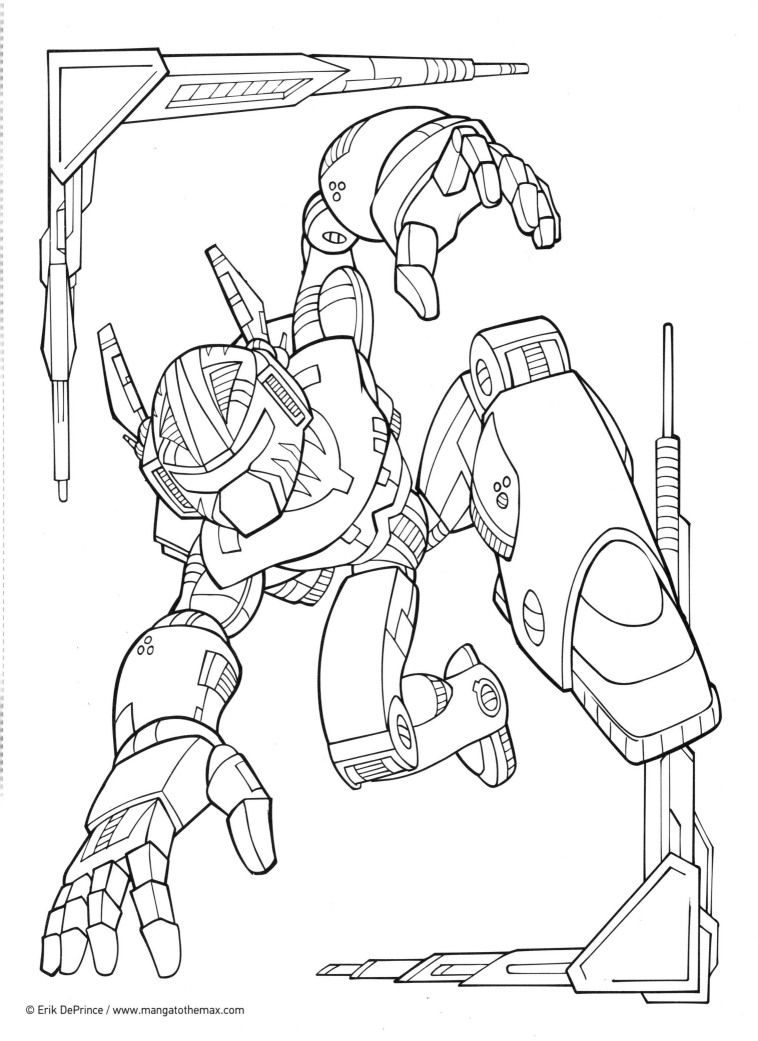

◀ **INFILTRATOR (NON-TRANSFORMED APPEARANCE)** *(previous page)*

STATS

- Robotic Class: AI (sentient)
- Size: 6.5 ft. (2 m)
- Offensive Capabilities: Deception via Holo-Projectors
- Defensive Capabilities: Deception via Holo-Projectors

PROFILE

An expert at undercover work, the Infiltrator is the perfect spy. With twelve hologram projectors under its exoskeleton, it uses advanced alien technology to project a visual and physical holographic illusion that changes its perceived appearance so it can embed itself within criminal groups. Everyone around the Infiltrator sees and feels whatever form—including human—that the Infiltrator projects. Holo-projectors only change the wearer's body, not any items or weapons they might be holding, so Infiltrators tend to be experts in hand-to-hand combat and martial arts, enabling them to make quick appearance changes without giving themselves away. However, in order to truly blend in convincingly, the Infiltrator cannot just look like someone else—it must also act like someone else. To do this, each Infiltrator is extremely knowledgeable about all alien cultures and languages and has the ability to quickly observe and mimic the behaviors of those around it.

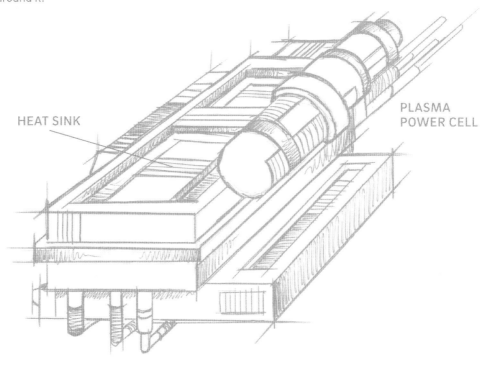

HEAT SINK

PLASMA POWER CELL

▲ **HOLOGRAPHIC PROJECTOR** *(above)*

A combination of several different alien technologies, each Holo-Projector is about 5 inches (12.5 cm) long and must be installed all around the wearer's body to project a 360-degree illusion. The biggest drawback to this incredible technology is that despite several heat sinks drawing heat away from the components, the holographic system can only run for a few hours a day before it overheats from its massive energy consumption.

Draw your own awesome robot and use the back of the page to create its profile.

STATS

- Robotic Class: _____

- Size: _____

- Offensive Capabilities: _____

- Defensive Capabilities: _____

PROFILE
